Field Guides to Finding a New Career

Arts and Entertainment

By S. J. Stratford

Ferguson Publishing
An imprint of Infobase Publishing

Field Guides to Finding a New Career: Arts and Entertainment

Ferguson
An imprint of Infobase Publishing
132 West 31st Street
New York, NY 10001

Library of Congress Cataloging-in-Publication Data

Stratford, S. J.
 Arts and entertainment / by S. J. Stratford
 p. cm. — (Field guides to finding a new career)
 Includes bibliographical references and index.
 ISBN-13: 978-0-8160-7595-9 (hardcover : alk. paper)
 ISBN-10: 0-8160-7595-6 (pbk. : alk. paper)
 1. Arts—Vocational guidance. 2. Arts publicity—Vocational guidance. I. Title.
 NX163.S77 2009
 700'.23—dc22

 2008032008

Ferguson books are available at special discounts when purchased in bulk quantities for businesses, associations, institutions, or sales promotions. Please call our Special Sales Department in New York at (212) 967-8800 or (800) 322-8755.

You can find Ferguson on the World Wide Web at http://www.fergpubco.com

Produced by Print Matters, Inc.
Text design by A Good Thing, Inc.
Illustrations by Molly Crabapple
Cover design by Takeshi Takahashi

Printed in the United States of America

Bang PMI 10 9 8 7 6 5 4 3 2 1

This book is printed on acid-free paper.

Contents

Introduction: Finding a New Career

Today, changing jobs is an accepted and normal part of life. In fact, according to the Bureau of Labor Statistics, Americans born between 1957 and 1964 held an average of 9.6 jobs from the ages of 18 to 36. The reasons for this are varied: To begin with, people live longer and healthier lives than they did in the past and accordingly have more years of active work life. However, the economy of the twenty-first century is in a state of constant and rapid change, and the workforce of the past does not always meet the needs of the future. Furthermore, fewer and fewer industries provide bonuses such as pensions and retirement health plans, which provide an incentive for staying with the same firm. Other workers experience epiphanies, spiritual growth, or various sorts of personal challenges that lead them to question the paths they have chosen.

Job instability is another prominent factor in the modern workplace. In the last five years, the United States has lost 2.6 *million jobs*; in 2005 alone, 370,000 workers were affected by mass layoffs. Moreover, because of new technology, changing labor markets, ageism, and a host of other factors, many educated, experienced professionals and skilled blue-collar workers have difficulty finding jobs in their former career tracks. Finally—and not just for women— the realities of juggling work and family life, coupled with economic necessity, often force radical revisions of career plans.

No matter how normal or accepted changing careers might be, however, the time of transition can also be a time of anxiety. Faced with the necessity of changing direction in the middle of their journey through life, many find themselves lost. Many career-changers find themselves asking questions such as: Where do I want to go from here? How do I get there? How do I prepare myself for the journey? Thankfully, the Field Guides to Finding a New Career are here to show the way. Using the language and visual style of a travel guide, we show you that reorienting yourself and reapplying your skills and knowledge to a new career is not an uphill slog, but an exciting journey of exploration. No matter whether you are in your twenties or close to retirement age, you can bravely set out to explore new paths and discover new vistas.

Though this series forms an organic whole, each volume is also designed to be a comprehensive, stand-alone, all-in-one guide to getting

motivated, getting back on your feet, and getting back to work. We thoroughly discuss common issues such as going back to school, managing your household finances, putting your old skills to work in new situations, and selling yourself to potential employers. Each volume focuses on a broad career field, roughly grouped by Bureau of Labor Statistics' career clusters. Each chapter will focus on a particular career, suggesting new career paths suitable for an individual with that experience and training as well as practical issues involved in seeking and applying for a position.

Many times, the first question career-changers ask is, "Is this new path right for me?" Our self-assessment quiz, coupled with the career compasses at the beginning of each chapter, will help you to match your personal attributes to set you on the right track. Do you possess a storehouse of skilled knowledge? Are you the sort of person who puts others before yourself? Are you methodical and organized? Do you communicate effectively and clearly? Are you good at math? And how do you react to stress? All of these qualities contribute to career success—but they are not equally important in all jobs.

Many career-changers find working for themselves to be more hassle-free and rewarding than working for someone else. However, going at it alone, whether as a self-employed individual or a small-business owner, provides its own special set of challenges. Appendix A, "Going Solo: Starting Your Own Business," is designed to provide answers to many common questions and solutions to everyday problems, from income taxes to accounting to providing health insurance for yourself and your family.

For those who choose to work for someone else, how do you find a job, particularly when you have been out of the labor market for a while? Appendix B, "Outfitting Yourself for Career Success," is designed to answer these questions. It provides not only advice on résumé and self-presentation, but also the latest developments in looking for jobs, such as online resources, headhunters, and placement agencies. Additionally, it recommends how to explain an absence from the workforce to a potential employer.

Changing careers can be stressful, but it can also be a time of exciting personal growth and discovery. We hope that the Field Guides to Finding a New Career not only help you get your bearings in today's employment jungle, but set you on the path to personal fulfillment, happiness, and prosperity.

How to Use This Book

Career Compasses

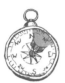

Each chapter begins with a series of "career compasses" to help you get your bearings and determine if this job is right for you, based on your answers to the self-assessment quiz at the beginning of the book. Does it require a mathematical mindset? Communication skills? Organizational skills? If you're not a "people person," a job requiring you to interact with the public might not be right for you. On the other hand, your organizational skills might be just what are needed in the back office.

Destination

A brief overview, giving you an introduction to the career, briefly explaining what it is, its advantages, why it is so satisfying, its growth potential, and its income potential.

You Are Here

A self-assessment asking you to locate yourself on your journey. Are you working in a related field? Are you working in a field where some skills will transfer? Or are you doing something completely different? In each case, we suggest ways to reapply your skills, gain new ones, and launch yourself on your new career path.

Navigating the Terrain

To help you on your way, we have provided a handy map showing the stages in your journey to a new career. "Navigating the Terrain" will show you the road you need to follow to get where you are going. Since the answers are not the same for everyone and every career, we are sure to show how there are multiple ways to get to the same destination.

Organizing Your Expedition

Fleshing out "Navigating the Terrain," we give explicit directions on how to enter this new career: Decide on a destination, scout the terrain, and decide on a path that is right for you. Of course, the answers are not the same for everyone.

Landmarks

People have different needs at different ages. "Landmarks" presents advice specific to the concerns of each age demographic: early career (twenties), mid-career (thirties to forties), senior employees (fifties) and second-career starters (sixties). We address not only issues such as overcoming age discrimination, but also possible concerns of spouses and families (for instance, paying college tuition with reduced income) and keeping up with new technologies.

Essential Gear

Indispensable tips for career-changers on things such as gearing your résumé to a job in a new field, finding contacts and networking, obtaining further education and training, and how to gain experience in the new field.

Notes from the Field

Sometimes it is useful to consult with those who have gone before for insights and advice. "Notes from the Field" presents interviews with career-changers, presenting motivations and methods that you can identify with.

Further Resources

Finally, we give a list of "expedition outfitters" to provide you with further information and trade resources.

Make the Most of Your Journey

Everyone on Earth is drawn to creative expression. It is what distinguishes us as humans. The idea of actually pursuing a career in the arts and entertainment world can be daunting. Everyone knows someone who is talented and dedicated, yet whose career went nowhere. Or they know people who have struggled for years before finally breaking through, and even then those creative people did not make much money. Such stories can dissuade you from pursuing a career doing something you love, especially if you have not dedicated yourself to it from an early age. However, for every such story, there will be someone who decided to stop what they were doing and go back to pursuing their first love…and never looked back.

No matter what sort of work you are interested in, be it sports promotion or choreography, one thread remains constant—you have to love it. Serious artistic careers are not for casual dabblers. Jobs that pay well are fiercely competitive, and the passion helps drive you. The love also focuses your dedication. One of the main reasons people do not succeed in the field is because they give up. Dedication and perseverance may sound like clichés, but they are what finally get a person paying work.

To forge a career in arts and entertainment, you need to be practical and capable of compromise. Perhaps you paint like Rembrandt, but the only paying job you can land is as an assistant art director for a small ad agency. However, that job pays you to work in the medium you adore. Plus, you can paint and approach galleries in your spare time. Or you are a wonderful artistic photographer, but the only way you can find to pay the rent is by taking actors' headshots. Working in theater is all about compromise, no matter how successful you are. A costumer, make-up designer, or choreographer must tailor his or her vision to that of the director and producer. From community theater to Broadway, your job will always involve give and take and working closely with others to help create a successful show.

Additionally, in spite of the stereotypes and obvious jokes, most jobs in arts and entertainment do not allow for the storied "artistic temperament." No one has the time or patience to deal with divas or snobs. An aspiring fashion designer can be the next Valentino or Donna Karan, but you may still start out making patterns for a large firm or hustling

your designs from boutique to boutique, hoping someone will sell them. Along the way, you have to prove yourself as someone people want to work with, and want to be part of their artistic community.

That community is another aspect of what can make working in arts and entertainment so delightful. You may not be getting paid much, but you are an integral part of a devoted group working towards a common goal. A particular sort of energy arises when creative people bring their talents together, which is why the experience of live theater can be so exhilarating for audience, cast, and crew alike. Many in the field describe the joys of the experience, even though they have to take other jobs to pay the rent. The hands-on work, difficult as it can be, compares to nothing else.

In almost every artistic field, those who succeed are good at handling pressure and quick at solving problems. Theater, especially, is notorious for disasters. The Oscar-winning film *Shakespeare in Love* nailed the industry exactly in this exchange:

Henslowe: Allow me to explain about the theater business. The natural condition is one of insurmountable obstacles on the road to imminent disaster.
Fennyman: So what do we do?
Henslowe: Nothing. Strangely enough, it all turns out well.
Fennyman: How?
Henslowe: I don't know. It's a mystery.

And things usually do turn out well, but an actor, stage manager, costumer, or choreographer must always be prepared for the worst. Even on Broadway, props break, lights malfunction, costumes rip, or an actor forgets a line. A dresser and actress in a Broadway show described a lightning-quick costume change in which a sweet little old nineteenth-century lady was briefly transformed into a Turkish sultan. The show was in previews and the costume had just been altered that day. In fewer than five minutes, the dresser had to help the actress out of her dress and wig and into an elaborate robe, headdress, and beard. The actress, an old pro, had no time to check the beard was secure before going on stage. Although the change was strictly for laughs, and she had no lines, she spent the entire three minutes terrified the beard was going to fall off and spoil the joke. From the tiniest local theater to a major stage, everyone must be

aware of the pitfalls, as well as the pleasures, of working live and be able to work with and around the inevitable problems.

Other jobs in the arts are not much easier. Artists, photographers, writers, and editors will all work to deadlines and must anticipate changes. When you are working for someone else, you must be flexible and able to change gears on a moment's notice.

Another difficult aspect of working in the arts and entertainment field is learning to handle criticism. From an unpaid intern to a well-paid union member, almost every single job discussed in this book entails some level of criticism, and you have to be someone who can accept it graciously and work with it. As the chapter on being a critic says, the ideal of criticism is to be an integral part of the community, and whether you are working in food, film, or fashion, the goal is to make it all better. As a writer, artist, or costumer, you may disagree with whatever criticism is offered, but you must be able to listen to it, discuss it, and work with it. Even if you initially disagree, consideration may show just how right the criticism is, so keep an open mind.

Additionally, you cannot let criticism get you down. While you need a thick skin, you also have to be realistic and understand that not everything you do will be universally liked. More often than not, criticism will help make your work better in the end—but you have to give it its due.

So how do you break into your chosen field? Most of the time, in addition to dedication, hard work, and a little luck, you have to start at the bottom and work your way up. You may have already worked hard paying dues (and debts) as a lawyer, accountant, or businessperson. Although you may certainly have skills and talents that will translate and help put you near the front of the pack, you will still face a learning curve in your new career. The good news is that, even though you may initially have to volunteer to gain the required experience, your skill set will help propel you up the ladder that much faster.

Many opportunities must be created. The fashion designer profiled in this book started growing her business by taking dresses she had sewn herself around to boutiques and trade shows. The photographer coupled being an unpaid assistant to established photographers with sending out e-mails to his wide range of contacts telling them that he had left marketing and was now doing photography. As fun as a career in the arts world can be, you cannot be the shy, retiring sort. You have to be someone ready and willing to throw yourself out there and possibly fail.

You are less likely to fail if you give yourself time to really learn your craft. Perhaps you have been drawing or writing or sewing since you were a child and have kept it up as a hobby throughout your career. That will help you tremendously as you take the steps to turn the hobby into a new occupation. However, drawing for fashion or costume design, or as an artist for hire, requires different techniques, as does the writing or sewing. Taking classes in journalism or design, or offering yourself as an apprentice, are excellent ways to really learn the ropes of your chosen path. You must be prepared to make a lot of mistakes, and when you are working as an unpaid assistant mistakes are expected and part of the learning process. The more experienced people for whom you are working will assure you that some errors are okay and show you what you can do in the future to avoid such mistakes.

If you are in your thirties, forties, or fifties, the last thing in which you may be interested is volunteering yourself as someone's apprentice or intern. That is for college students or twenty-somethings, right? Nothing could be further from the case. People of all ages get their feet wet in a new profession by working for free. Obviously, some careful financial planning is necessary before taking this step, but if you have skills and knowledge about the field you are entering, you will very likely not have to work unpaid for long. It is a great way to break in, however, and it is a good icebreaker, too. People will see how serious you are if you ask for an unpaid internship, because there is no question that you want to learn and are ready to do whatever it takes to become a professional. When they see that you are serious, they will take you seriously in turn. Furthermore, as you quickly prove how capable you are, the good word of mouth will follow and you will see your career take off.

As in all things, and especially all things arts-related, there are no guarantees. What makes the arts and entertainment worlds so exciting—their unpredictability—is also what renders them frustrating for those who would spend their lives there. But if you come to your new profession with an open mind, ready to take what comes and realizing that there will be periods of ups and downs, you will find yourself at the threshold of a wonderful new adventure.

Self-Assessment Quiz

I: Relevant Knowledge

1. How many years of specialized training have you had?
 (a) None, it is not required
 (b) Several weeks to several months of training
 (c) A year-long course or other preparation
 (d) Years of preparation in graduate or professional school, or equivalent job experience

2. Would you consider training to obtain certification or other required credentials?
 (a) No
 (b) Yes, but only if it is legally mandated
 (c) Yes, but only if it is the industry standard
 (d) Yes, if it is helpful (even if not mandatory)

3. In terms of achieving success, how would rate the following qualities in order from least to most important?
 (a) ability, effort, preparation
 (b) ability, preparation, effort
 (c) preparation, ability, effort
 (d) preparation, effort, ability

4. How would you feel about keeping track of current developments in your field?
 (a) I prefer a field where very little changes
 (b) If there were a trade publication, I would like to keep current with that
 (c) I would be willing to regularly recertify my credentials or learn new systems
 (d) I would be willing to aggressively keep myself up-to-date in a field that changes constantly

5. For whatever reason, you have to train a bright young successor to do your job. How quickly will he or she pick it up?
 (a) Very quickly
 (b) He or she can pick up the necessary skills on the job
 (c) With the necessary training he or she should succeed with hard work and concentration
 (d) There is going to be a long breaking-in period—there is no substitute for experience

II: Caring

1. How would you react to the following statement: "Other people are the most important thing in the world?"
 (a) No! Me first!
 (b) I do not really like other people, but I do make time for them
 (c) Yes, but you have to look out for yourself first
 (d) Yes, to such a degree that I often neglect my own well-being

2. Who of the following is the best role model?
 (a) Ayn Rand
 (b) Napoléon Bonaparte
 (c) Bill Gates
 (d) Florence Nightingale

3. How do you feel about pets?
 (a) I do not like animals at all
 (b) Dogs and cats and such are OK, but not for me
 (c) I have a pet, or I wish I did
 (d) I have several pets, and caring for them occupies significant amounts of my time

4. Which of the following sets of professions seems most appealing to you?
 (a) business leader, lawyer, entrepreneur
 (b) politician, police officer, athletic coach
 (c) teacher, religious leader, counselor
 (d) nurse, firefighter, paramedic

5. How well would you have to know someone to give them $100 in a harsh but not life-threatening circumstance? It would have to be...
 (a) ...a close family member or friend (brother or sister, best friend)
 (b) ...a more distant friend or relation (second cousin, coworkers)
 (c) ...an acquaintance (a coworker, someone from a community organization or church)
 (d) ...a complete stranger

III: Organizational Skills

1. Do you create sub-folders to further categorize the items in your "Pictures" and "Documents" folders on your computer?
 (a) No
 (b) Yes, but I do not use them consistently
 (c) Yes, and I use them consistently
 (d) Yes, and I also do so with my e-mail and music library

2. How do you keep track of your personal finances?
 (a) I do not, and I am never quite sure how much money is in my checking account
 (b) I do not really, but I always check my online banking to make sure I have money
 (c) I am generally very good about budgeting and keeping track of my expenses, but sometimes I make mistakes
 (d) I do things such as meticulously balance my checkbook, fill out Excel spreadsheets of my monthly expenses, and file my receipts

3. Do you systematically order commonly used items in your kitchen?
 (a) My kitchen is a mess
 (b) I can generally find things when I need them
 (c) A place for everything, and everything in its place
 (d) Yes, I rigorously order my kitchen and do things like alphabetize spices and herbal teas

4. How do you do your laundry?
 (a) I cram it in any old way
 (b) I separate whites and colors

(c) I separate whites and colors, plus whether it gets dried
(d) Not only do I separate whites and colors and drying or non-drying, I organize things by type of clothes or some other system

5. Can you work in clutter?
(a) Yes, in fact I feel energized by the mess
(b) A little clutter never hurt anyone
(c) No, it drives me insane
(d) Not only does my workspace need to be neat, so does that of everyone around me

IV: Communication Skills

1. Do people ask you to speak up, not mumble, or repeat yourself?
(a) All the time
(b) Often
(c) Sometimes
(d) Never

2. How do you feel about speaking in public?
(a) It terrifies me
(b) I can give a speech or presentation if I have to, but it is awkward
(c) No problem!
(d) I frequently give lectures and addresses, and I am very good at it

3. What's the difference between *their, they're,* and *there*?
(a) I do not know
(b) I know there is a difference, but I make mistakes in usage
(c) I know the difference, but I can not articulate it
(d) *Their* is the third-person possessive, *they're* is a contraction for *they are,* and *there is* a deictic adverb meaning "in that place"

4. Do you avoid writing long letters or e-mails because you are ashamed of your spelling, punctuation, and grammatical mistakes?
(a) Yes
(b) Yes, but I am either trying to improve or just do not care what people think

(c) The few mistakes I make are easily overlooked

(d) Save for the occasional typo, I do not ever make mistakes in usage

5. Which choice best characterizes the most challenging book you are willing to read in your spare time?
 (a) I do not read
 (b) Light fiction reading such as the Harry Potter series, *The Da Vinci Code*, or mass-market paperbacks
 (c) Literary fiction or mass-market nonfiction such as history or biography
 (d) Long treatises on technical, academic, or scientific subjects

V: Mathematical Skills

1. Do spreadsheets make you nervous?
 (a) Yes, and I do not use them at all
 (b) I can perform some simple tasks, but I feel that I should leave them to people who are better-qualified than myself
 (c) I feel that I am a better-than-average spreadsheet user
 (d) My job requires that I be very proficient with them

2. What is the highest level math class you have ever taken?
 (a) I flunked high-school algebra
 (b) Trigonometry or pre-calculus
 (c) College calculus or statistics
 (d) Advanced college mathematics

3. Would you rather make a presentation in words or using numbers and figures?
 (a) Definitely in words
 (b) In words, but I could throw in some simple figures and statistics if I had to
 (c) I could strike a balance between the two
 (d) Using numbers as much as possible; they are much more precise

4. Cover the answers below with a sheet of paper, and then solve the following word problem: Mary has been legally able to vote for exactly half her life. Her husband John is three years older than she. Next year,

their son Harvey will be exactly one-quarter of John's age. How old was Mary when Harvey was born?
(a) I couldn't work out the answer
(b) 25
(c) 26
(d) 27

5. Cover the answers below with a sheet of paper, and then solve the following word problem: There are seven children on a school bus. Each child has seven book bags. Each bag has seven big cats in it. Each cat has seven kittens. How many legs are there on the bus?
(a) I couldn't work out the answer
(b) 2,415
(c) 16,821
(d) 10,990

VI: Ability to Manage Stress

1. It is the end of the working day, you have 20 minutes to finish an hour-long job, and you are scheduled to pick up your children. Your supervisor asks you why you are not finished. You:
(a) Have a panic attack
(b) Frantically redouble your efforts
(c) Calmly tell her you need more time, make arrangements to have someone else pick up the kids, and work on the project past closing time
(d) Calmly tell her that you need more time to do it right and that you have to leave, or ask if you can release this flawed version tonight

2. When you are stressed, do you tend to:
(a) Feel helpless, develop tightness in your chest, break out in cold sweats, or have other extreme, debilitating physiological symptoms?
(b) Get irritable and develop a hair-trigger temper, drink too much, obsess over the problem, or exhibit other "normal" signs of stress?
(c) Try to relax, keep your cool, and act as if there is no problem
(d) Take deep, cleansing breaths and actively try to overcome the feelings of stress

3. The last time I was so angry or frazzled that I lost my composure was:
 (a) Last week or more recently
 (b) Last month
 (c) Over a year ago
 (d) So long ago I cannot remember

4. Which of the following describes you?
 (a) Stress is a major disruption in my life, people have spoken to me about my anger management issues, or I am on medication for my anxiety and stress
 (b) I get anxious and stressed out easily
 (c) Sometimes life can be a challenge, but you have to climb that mountain!
 (d) I am generally easygoing

5. What is your ideal vacation?
 (a) I do not take vacations; I feel my work life is too demanding
 (b) I would just like to be alone, with no one bothering me
 (c) I would like to do something not too demanding, like a cruise, with friends and family
 (d) I am an adventurer; I want to do exciting (or even dangerous) things and visit foreign lands

Scoring:

For each category...

For every answer of *a*, add zero points to your score.
For every answer of *b*, add ten points to your score.
For every answer of *c*, add fifteen points to your score.
For every answer of *d*, add twenty points to your score.

The result is your percentage in that category.

Writer

Writer

Career Compasses

Find the path to a life in words.

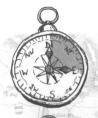

Caring about the craft and your commitment to excellent work (25%)

Communication Skills to put your work across to a readership of varying backgrounds and tastes (30%)

Organizational Skills to keep notes and changes in order as you write and rewrite and get opinions and feedback (25%)

Relevant Knowledge of the craft and the business (20%)

Destination: Writer

Whether you want to write a novel, a play, or become a columnist for a magazine or newspaper, it is all about wordplay. Opinions vary on whether it is harder to write fiction or nonfiction but everyone agrees that to write well—never mind getting paid for it—is far more challenging than it seems when you are just dreaming of the writer's life. You may have learned how to construct a sentence in grade school, but translating that

ability into an actual career is something else again. However, for those who do have the talent, skill, and all-important drive, the life of a writer can be deeply rewarding.

If you like to write, you probably already have a good sense of the type of writing you would like to do full time. You can choose several career paths, and the rise of the Internet has only increased possibilities. Unfortunately, fierce competition and an uncertain market mean that a lot of skilled writers are only finding work at wages that are sufficient at best. While it is true that a few writers will make good salaries, and no one should enter the field thinking they will get rich, it can be very frustrating to work for an online publication where you might earn $20 for an article that takes you several hours to write. If you are writing something in which you are genuinely interested, however, and get to write about it in a way that satisfies you, this can be a good way to build up clips.

Many say that magazine writing is not what it was. Decreased circulation and a decline in the standards of editing have meant the work is less satisfactory and not as well paid. This may be so, but a lot of magazine work is still out there for freelancers and full-time staff members. And for freelancers, a number of publications pay a dollar a word or more. These are not easy assignments to land, but they are goals to strive for.

One field that is constantly growing and pays well is technical writing. It does, of course, require specific skills, and quality writers who can intelligently discuss matters of business, law, technology, finance, and medicine are always in demand. This is good news for anyone interested in transitioning from one of those fields. Even better, this sort of writing tends to pay more than most writing jobs. If you are already a professional in medicine, law, business, or technology, the transition into tech writing can be comparatively easy, because you already have skills and knowledge of the business. You may find that approaching the field from a writer's angle will intrigue and energize you. Plus, you never know where you can eventually take this new career. Pulitzer Prize-winning science writer Natalie Angier, who majored in physics and now writes for the *New York Times*, brings accessibility and humor to what can be a difficult subject. The beauty of writing is that it can be very flexible and a career as a writer is very much what you make it.

If your heart is in fiction or drama, the reality is that this is a very difficult field in which to be successful, although it is by no means impossible. It can be very satisfying conjuring characters and a story from your

own imagination and then seeing that creation in print and knowing it is bringing pleasure to others. For many writers, short stories are a good way to begin getting published, even though you may not get paid, or will be paid very little. Initially, it is more important to be published than to make money, because having something in print is the key to getting published again and again. If you persevere, you will eventually start getting requests for new work, and you will be paid.

Some say the short story market, like so many other writing outlets, is not what it used to be. To a certain extent, this is true in that far fewer publications pay a substantial fee for a story. However, the rise of e-zines and the growth of "flash fiction" (stories that are 500 words or fewer) means that many markets are available for showcasing your work. Markets can be very specific, and some are more popular than others. Dark fantasy and science-fiction stories are often in high demand, although the markets that seek them tend not to pay well. However, the veritable explosion in comics and graphic novels can mean that gaining popularity as a writer in these genres will lead to bigger and better work. Likewise, you may turn your flair for fantasy or sci-fi to a longer format and produce novels, which are typically in demand.

Essential Gear

A writers' group. Writing is hard and lonely. At any time, but especially when you are just starting out, being in a good group that meets regularly can make all the difference. What you want is a collection of writers with whom you have a fairly similar mindset—people you trust to read your work and comment truthfully and constructively. A writers' group should be a safe and comfortable space where you can talk about goals, help each other maintain and achieve those goals, give suggestions for agents or editors to approach, and bounce around ideas. The group helps you with your focus and keeps you on track.

Romance is another genre that continues to be popular. If you have a good sense for story and the strict formula that defines the genre, you can learn to write these novels quickly and build an audience and a career.

Reading has changed, and so the market for mainstream fiction is in flux and getting a novel published is perhaps a bit harder than it once was. Still, the realities of modern publishing should not discourage you from pursuing a career as a writer. What has been true since the birth of the story remains true today—a good story told well is all that really matters. If you can write a strong story worth telling, you must persevere

and trust that it will find the publisher who values it, and, in due course, the audience who adores it. Just look J.K. Rowling, the author of the Harry Potter series. She is now one of the richest women in the world. Writing is hard and lonely and often frustrating, but the rewards can be tremendous and long-lasting.

You Are Here

Your journey to a career as a writer begins with a deep love of language and an interest in communication.

Do you know how to structure a piece from beginning to middle to end? Whether you are interested in fiction, nonfiction, books, or articles, the story is the same—it is not enough to have a good idea, you have to follow it through. Many successful writers say that this is not just half but a full 90 percent of the battle, especially if you are working on a book. Almost anyone can have the beginnings of an idea and even hammer out a strong chapter or two. But actually completing a project is harder than you might think. It requires structure, patience, and discipline. Even an essay or short article can be difficult to finish if your idea is not well-honed. Understanding and being able to structure a piece is key to being a good and successful writer.

Are you focused and a good self-starter? One key to being able to finish a project is to start. This is often easier said than done. When it is just you up against a blank page, or a half-written piece, it can be hard to get into the swing. You need daily motivation. Every day, no matter how tired you are or how badly the floor needs to be cleaned, you must sit down and do the work. If you are someone who has a hard time concentrating or getting yourself going, seeking full-time work as a writer may not be for you.

Are you curious and do you love research? One common denominator for writers in every area and genre is that they ask questions. Whether you have been given an assignment or are pursuing something on your own, you have to dig as deep as possible to bring the most detail and honesty to whatever you are doing. You have probably read work in both

fiction and nonfiction that felt incomplete and shallow. The way to avoid writing such work yourself is to delve into research and be excited about examining every angle until you know you are done.

Navigating the Terrain

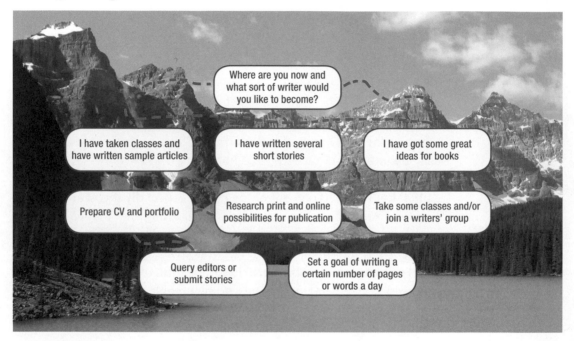

Where are you now and what sort of writer would you like to become?

I have taken classes and have written sample articles

I have written several short stories

I have got some great ideas for books

Prepare CV and portfolio

Research print and online possibilities for publication

Take some classes and/or join a writers' group

Query editors or submit stories

Set a goal of writing a certain number of pages or words a day

Organizing Your Expedition

Before you cozy up to your computer, make sure you are ready for anything.

Perfect your organizational skills. One of the most important aspects of organizing your expedition into the world of writing is being organized. The myth of the dreamy, flaky artist is just that: a myth. Or rather, you can be dreamy and flaky when it comes to other things in life, but where writing is concerned, if you are going to do it full time and intend on making a living, you have got to be focused, structured, and organized. Your organization needs to be twofold. You have to organize

both your workday and your work. Unless you are working for a paper or magazine and reporting regularly to an editor on a tight deadline, you are pretty much working for yourself. If you have not been given a deadline for a project, set your own. It can help to get a whiteboard and pin it over your work area. Use it to make a chart and note all that needs to get done before the projected deadline. That way, you know that whatever else happens on a given day, you also need to complete an outline, for example, or write five pages. Whatever the day's chore is, you must make sure it gets done. An outline is very useful, even for a short project. It can be as detailed as you like, so long as it works for you. It can also help to make notes on index cards and keep these at hand. You really cannot be too organized—especially because careful organization can help fight writer's block. If you have a detailed outline from which to work, you know exactly what is coming next in your project.

Be goal-oriented. Many writers like to set daily goals, like a certain number of pages or words. This is another handy trick for fighting writer's block, because if you sit down knowing that you are not going to get up again until you have written a page, no matter what is on that page, you will complete it. If you are learning focus and concentration, you can set mini-goals, like giving yourself one hour in which to do nothing but write. Mothers of small children who write for a living report that when you only have a certain amount of time during the day, like however long a child is napping, you learn to be spectacularly productive in that time. Ideally, you set goals for the day, the week, and the month.

When you have goals mapped out, you are more likely to achieve them. It is important to remember that, especially in a fiction project, the initial draft is not going to be top quality. This is fine, because your first and foremost goal is just finishing that draft. The main thing is knowing the work needs to be done and summoning the concentration to do it. Of course, you must not berate yourself when a goal is missed. Things happen. However, the best writers note that when they have a goal of five pages a day, it usually means that at least two pages will get written and, sometimes, ten. That is progress.

Learn to love the rewrite process. Many writing teachers will tell you that writing is rewriting. When you are just starting out, this can feel cumbersome and frustrating. You want to complete something and put

Notes from the Field

Noeleen G. Walder
State court reporter for *New York Law Journal*
New York, New York

What were you doing before you decided to change careers?

I worked as a commercial litigator for 12 years, mostly defending large corporate clients in contract disputes, securities litigation, etc. I worked as an associate for some large law firms, then six years ago became a contract lawyer (the equivalent of a freelancer), because I knew I wanted to transition out of the field and thought it would afford me more time and latitude to pursue other interests. I was exploring, networking, and looking for what might be out there, but I didn't know what I wanted to do.

Why did you change your career?

I wanted a career I felt passionate about. I felt the law was very technical, and not very intellectually satisfying. I didn't feel passionate about the cases I was working on even though they could be interesting. I didn't feel it was my calling. I didn't think carefully before going to law school. It was a default decision because I didn't know what to do after college. I should have taken time to think about what I wanted. And law notoriously has a very high rate of dissatisfaction.

How did you make the transition?

I felt I wanted to do something with writing. I knew I was a good writer and enjoyed it, but I wasn't sure which way to go. I'd taken a journalism course and was considering journalism school while also putting out a lot of inquiries, particularly to alumni. I let friends know I was looking for some kind of writing work. I asked a lot of questions about a lot of careers. Then my alumni association and the city bar association sponsored an event for lawyers who wanted to write. They announced the job at the *Journal* at this forum. I applied for it, and a month later, I got it. So things fell into place quickly, except that getting there took me a few years.

What are the keys to success in your new career?

When you're looking for that initial transition opportunity, don't limit yourself, because you never know what might come up. At the forum I attended, one writer explained how he'd gotten his job by applying for another job. The head of the alumni association stressed that you should apply for jobs even if you don't have the requisite experience because you never know. Even if you get turned down, that's an opportunity to write a follow-up, which gets you a contact and might lead to opportunities down the line. You should ask for as many informational interviews as you can because people love to talk about themselves and their work. It's a non-threatening way of asking for help. Don't underestimate internships, either. I was told by a lot of people that this would be a good way to get my foot in. It didn't matter that I was in my thirties—there are people older than that working as interns. It shows you're serious, it will build your résumé, and if you do well, you can get great recommendations. Even a rejection is a potential contact and opportunity. The *Journal* wasn't sure they wanted to hire me even after a second round of interviews and seeing my submitted samples because I didn't have enough experience. I told them I'd work as hard as I had to to succeed. I said I'd get a tutor, take classes, whatever it took. Sometimes you have to convince someone to take a risk on you.

When you get the job, be prepared for a lot of hard work. Writing seems solitary, but it's actually very collaborative, especially in journalism. You have to be open to constructive criticism and be really good at meeting deadlines. I was used to juggling and deadlines, which helped a lot. I hadn't done interviews, but I knew how to question people. You also have to be able to tailor your particular style to the job. I was used to advocacy-based writing and have had to learn to write more neutrally. Even once you have a job, you still have to network. I have to put myself out there so that when a story breaks, people know to come to me; or if I call them for an interview, they'll give me their time. What comes around goes around. You help someone and they'll help you. Finally, the world really is much smaller than you think and you never know whom you'll run into when, so you want to try and keep everyone thinking as well of you as possible.

it out there, not rewrite and rewrite and rewrite. But the truth is rewriting makes your work better. In many ways, rewriting is easier, because the bones of the piece are already in place. You just need to perfect the flesh. This may take dozens of tries. Be patient and trust the process because it will get easier and faster, and you are more likely to become a paid writer if you are an excellent rewriter.

Landmarks

If you are in your twenties . . . You may notice that a number of people your age publish novels. How good they are is another question. Generally speaking, your twenties is a good time to learn the craft and try your hand at several different aspects to find what suits you. Not everyone who is a whiz at short stories can write a novel and vice-versa. But working on stories is a good way to perfect your technique and focus you on where you would like to go.

Essential Gear

A blog or Web site. It is not a given, but many writers, especially those trying to make a career of writing, find that a blog or regularly updated Web site is useful. A number of writers have gotten so much attention from their blogs, they are now making money just from blogging. Others find that it is easy publicity and a good way to build notice and a fan base. It keeps you connected and can create a community, but also, a blog is yet another way in which you are forced to write regularly, even if the work you hope to do is not going as well as you would like. All writing is at least good practice, so if nothing else, you can feel productive.

If you are in your thirties or forties . . . You probably have excellent experience to call upon for both fiction and nonfiction writing. If you are a parent, writing can be a calming and sometimes lucrative sideline, allowing you flexibility. Huge numbers of publications are geared for parents, and they all need writers, so you can build a clip file quickly.

If you are in your fifties . . . This is a great time for someone with a lot of experience and knowledge of a specialized skill to turn that knowledge into a writing career. Many niche markets and trade magazines are out there, so you should be able to find a publication that suits you. If you feel your writing skills are rusty, take some classes. You may be pleasantly surprised how quickly you take to writing about something you know very well.

If you are over sixty . . . If you have time on your hands, now is the perfect time to delve into the world of fiction. You have decades of interesting experiences to call upon, and your take will be more unique than what the so-called "hot" writers are putting out there. Yes, there are trends, but if you have a story to tell and know how you want to tell it, you may soon be one of the "hot" writers yourself.

Further Resources

Writer's Market Published annually, this 80-year-old source book for writers has listings and information on publishers, magazines, literary agents, newspapers, syndicates, screenwriting, playwriting, and greeting card writing. It includes keys to successful query letters, advice on fees, and articles and interviews with successful writers. It is available in all bookstores, libraries, and online.

Writers' Resources A comprehensive Web site for both aspiring and professional writers, journalists, and editors. Includes tips, tutorials, news, and links. http://www.writersresources.com

Writing.com Offering an online community for writers at all levels. You can display your writing as well as connect with other writers. http://www.writing.com

On Writing **by Stephen King** The master of horror fiction's memoir is also a great lesson in all aspects of writing, even if you are not interested in writing fiction. It is also a fun read.

Editor

Editor

Career Compasses

Find the path to a life working with words.

Relevant Knowledge of your given area and its parameters and trends, as well as structure, narrative, and syntax (30%)

Caring about the craft and your commitment to excellent work (20%)

Communication Skills to work with writers and help them shape their work into a cohesive whole (30%)

Organizational Skills to keep notes and changes in order as you write and rewrite and get opinions and feedback (20%)

Destination: Editor

An editor can work for a newspaper, magazine, or publishing house, and the work will vary in terms of detail and schedule, but one thing will always be constant—an editor's job is to read, consider, edit, and sometimes rewrite the work of writers. In certain circumstances, an editor might also do original writing. Editing is a demanding job with a lot of responsibility that often does not pay as well as it ought to given the

work that is involved, but you can certainly make a decent living at it. Moreover, if you love reading and the power of language and the written word, editing can be a dream job.

Editorial duties vary throughout the industry. A magazine editor might plan content and review submitted ideas, as well as review and edit drafts. In the book world, an editor will take submissions from literary agents or, occasionally, directly from an author, and decide whether or not to present it to the board as a candidate for publication. A newspaper will have a number of editors: an executive editor who acts as director; assistant editors who oversee individual subjects, such as the arts or international news; managing editors, who coordinate the functioning of the news department; assignment editors who delegate stories to reporters; and copy editors who read and edit a story for accuracy, content, grammar, and style. In a smaller paper or magazine, a single editor may be responsible for most of this work, with copy editors employed in a freelance capacity.

Essential Gear

Computer skills. Most editing is done on computer nowadays, and to be employable, every aspiring editor must be comfortable with electronic editing. The dominant program is Microsoft Word. You should familiarize yourself with its capabilities, particularly the "track changes" and "comment" functions. Track changes shows anyone looking at the document what changes you have made and allows them to accept or reject each change. The comment function allows you to insert comments in the text. Comments typically take the form of queries to the author or other editors or special instructions to proofreaders or designers.

Most aspiring editors start off as editorial assistants or copy editors. Publishing enterprises tend to favor candidates who have a degree in English, assuming they will have a good grasp of grammar and sentence structure and be quick and concise in improving written material. That said, any degree in the liberal arts, especially journalism and communications, is usually a door-opener on a résumé. Editorial assistants with smaller or online-based media may compile wire service articles, answer phones, and perform other basic office assistant duties. Copy editors may do some research and fact-checking and prepare copy for print. Copy editors working for book publishers often read and evaluate manuscripts, proofread, and handle correspondence.

The work environment can vary widely. If you work for a major publishing house or magazine, you are going to be situated in a relatively comfortable office environment (although when you start out, you will probably be in a cubicle, rather than your own office). Many busy publishing environments will be cramped and noisy, especially if you are working for an online publication. The good news is that e-mail and other forms of electronic communications mean that much of your work can be done at home, or wherever you like. You do need to be good with computers and up to date on software and Internet usage, however. Furthermore, for publications that require an editor who can perform a number of tasks, some skill at Web site design and computer graphics or other technical abilities is necessary. The more you know about software, graphics, animation, and electronic publishing, the more likely it is you can get and keep a good editing job.

Many editors learn their trade working on high school and college papers and magazines, as well as local papers. Although this work can be unpaid, it is still invaluable training for entering the world of publishing. Often experience like this shows that you have the skills to manage a lot of different text and meet tight deadlines. Also, your background should demonstrate that you have good judgment, ethics, and polish.

If your first editing job is for a large company, you will likely begin as an editorial assistant. Your duties can be widely varied, including managing phones and files and other general assistant tasks, along with fact-checking, research, liaising with authors, and copyediting. It may take longer than you would like to advance, but the good news in working for a big and busy organization is that there is plenty of room for advancement, especially if you consistently prove yourself and show dedication and enthusiasm. You do not have to worry that the job will be anything like that held by Anne Hathaway in *The Devil Wears Prada*. Your boss might be demanding, but most major editors just want an assistant who works hard and knows his or her stuff. You may put in long hours, but you can still have a life.

When working for a smaller group, you will probably have a lot more responsibility from day one. This can be an invigorating challenge and an excellent starting point, but if only you and another editor are the business, you may find little space for promotion and possibly not much in the way of a raise. Depending on the nature of the work, you may also

expect to work long and irregular hours. Putting a small magazine to bed might entail some very late nights. However, you will quickly gain excellent experience that will catapult you ahead of competition if you do a wider job search after a few years.

What with the growth in technical writing, blogging, and other on-line-based media, the need for editors is expanding. However, many non-technical, online-based media do not pay as well as traditional editing jobs, and editing has never been considered a road to wealth as it is. Editors for major newspapers, magazines, or authors do very well, but the bulk of editors only earn respectable, but not large, salaries. If you love words and the process of disseminating information in any capacity, the rewards of editing are immeasurable.

You Are Here

You can begin your journey into editing from a love of language and obsession with good writing.

Do you have a degree in English, journalism, or a related field? For most editors, a degree in the liberal arts, especially English, is the natural first step into the profession. Being well read and schooled in criticism can mean you have developed a strong sense of judgment and can assess a variety of writing with equal pleasure and consideration. Most of the best editors who work in fiction have a passion for literature and have read widely and deeply, so as to not only see, but "sense" good writing when it crosses their desks. It is not an absolute given. Editors can certainly be short-sighted. The first Harry Potter book was turned down by 12 publishing houses before Bloomsbury decided to publish it. To be fair, children's books do not often make much money. J. K. Rowling's editor even advised she take a day job. Overall, however, a strong editor in fiction should have the background and expertise to know a diamond, whether it is in the rough or not.

Are you meticulous and extremely detail-oriented? When it comes to the written word, the devil really is in the details and every detail counts. Nearly all editors have to do at least some copyediting (and you can do pretty well just as a professional copyeditor), and to be good at it,

you have to be a stickler for accuracy. In these days of spell check, basic proofreading and copyediting get the short shrift. Worse, even large publishing houses are cutting costs by abandoning in-house, full-time copyeditors. The copyeditor's job goes beyond catching basic grammar mistakes. They have to look for factual errors as well. If a book has a scene set during the Battle of Britain but taking place in 1942, that is a serious error that a good copyeditor should catch. Incorrect timelines, problems in geography, or any improbabilities or impossibilities are all problems that these professionals must flag when reading a manuscript. These should all be discussed with the writer long before the book or piece reaches the galley stage when pages are typeset.

Are you tactful and encouraging? Writers understand that no piece is perfect from the outset, and they know your job is to help them achieve final perfection. You have to be the sort of person who can guide with firm gentleness. Showing tact and encouragement will help you built and maintain a long relationship with writers.

Navigating the Terrain

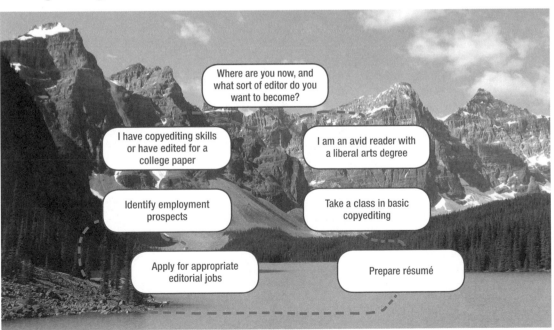

Notes from the Field

Martin della Valle
Project manager, CanYouProofThis.com
Los Angeles, California

What were you doing before you decided to change careers?

My career path was long and anything but straightforward. I waited tables, tended bars, collated junk mail, and even managed a small cattle farm in Australia for a year. At some point, I went back to school to get my master's in biology. I was only a few credits short when I decided I absolutely had to go to film school instead. I did that, made some tiny films that went nowhere and ended up working as an assistant at a movie production company in Los Angeles, setting up meetings, reading and writing coverage on screenplays, organizing my boss' life, etc. On the side I was still trying to find success as a screenwriter.

Why did you change your career?

When the production company temporarily ran short on money because yet another high-profile movie fell apart shortly before it was supposed to start shooting, I decided it was time for me to look around. But at the same time I also realized that I was feeling only lukewarm about the prospect of continuing to work as the tiniest cog in the movie-industry machinery. I'd done some proofreading before and was editing some scripts, so I thought maybe I could do something with those skills.

How did you make the transition?

While I was still half-heartedly looking for other film-industry-related jobs, some people who had heard that I was a decent proofreader offered me some freelance work proofing their novels. I took it because I needed the money and because it sounded like interesting enough work. Then a friend who was doing some freelance work for MGM's Home Entertainment division recommended me to them, and they

hired me as a proofreader/copyeditor because they needed someone who was good and fast and who knew movies. The workload expanded to the point where I managed a team of proofreaders, although we also edited, researched, and wrote. At the same time, my partner and I started an online proofreading and copyediting business, which has grown to the point where major publishers, businesses, and law firms use our services regularly.

What are the keys to success in your career?

Educate yourself! Don't assume you're a good proofreader or copyeditor just because you find typos in the newspaper, or you'll fail every time. There are style guides you need to be aware of (*Chicago Manual of Style* or CMS, AP or Associated Press, APA, MLS, Oxford, etc) in order to be employable. You should know at least CMS and one more. If you want to copyedit in journalism, AP style is a must. Don't be lazy. Stay current and be willing to learn. Accept a client's preferences, even if you don't like them. Acknowledge that you can't be an expert in everything and that you can't be the perfect copyeditor for every type of document. Know your technology. The good, old-fashioned proofreaders working with paper and a red pen will have a hard time finding work as a freelancer these days. It's important that you know how to do basic formatting tasks or activate "Track Changes" in a Word document, how to mark up a PDF, and how to do an Internet search for a quick fact check. Remember that the documents you work on are not yours, but your customer's. Don't rewrite them until they read like you wrote them. Respect the writer's voice and intent, and never replace his or her thoughts or arguments with your own. If you expect to get rich working as a proofreader, copyeditor, or editor, you're very wrong. If you think you never miss anything, you're even more wrong. And if you think you must be just about the best in the business, you probably have no idea of all the things you don't know yet.

Organizing Your Expedition

Have your kit ready before you begin to travel.

Gather your reference materials. Even if your main interest as an editor is in acquisitions and dealing with writers, you should still be familiar with all the style guides and forms of usage. The most common style guides are the *Chicago Manual of Style* and the *Associated Press Style Guide*, also known as the AP guide. The latter is used by newspapers and other journalistic organizations, although the *New York Times* has its own style guide. Style guides are also published by various organizations, including the Modern Language Association and the American Psychological Association. The granddaddy of style guides is *The Elements of Style* by William Strunk and E. B. White, which dates back to the 1950s. Often called simply "Strunk and White," publishers and editors consider this book one of the most important and influential style guides. Many magazines and publishing houses and organizations have their own in-house style guides, which are usually based on one of the classic guides with additions geared toward their specific publication needs. For example, the DVD divisions at film studios set up guidelines for noting awards, release dates, and complicated trademarks and copyrights. They also have to adhere to publications rules established by the Academy of Motion Picture Arts and Sciences. Wherever you work, you will have to know and be able to apply style.

Take a copyediting course. Even if your interest is not in copyediting, having the skills will be extremely useful. You will most likely start as a copyeditor or do some copyediting as part of your job. Knowing various styles is great, and the *Chicago Manual* will teach you proofreading marks (doctors say "stat" but editors say "stet"). A proper class will ground you in the basics of the work and give you guidelines you can apply to any aspect of the career. You should always be aware of certain pitfalls, such as mistakes in numbered lists, citations of dates, footnotes that do not align, and other errors. Many firms, large or small, will want you to take an editing test as part of the application process. Taking a class will help you refine your abilities and train your eyes and brain so that you will be ready to tackle your new editing job.

Determine your destination. Basic editing skills will help you in whatever capacity you wish to work, but if you determine your preference for fiction or nonfiction work, you can hone your skills accordingly. If you thrill to a fast-paced, information-based environment, you should set your sights on working for a newspaper, wire service, or online-based journal. If you love the idea of reading essays or novels all day long, you should apply for work in a publishing house. Take into account your other skills. Do you have knowledge of medicine, law, or science? Many academic publishers and journals specialize in such fields and are always looking for quality editors with an extensive knowledge base. Law firms employ many editors and proofreaders to review and correct reams of legal documentation. Computer and technical companies hire editors to improve their manuals. Tailor your search and résumé according to your interests and special knowledge.

Landmarks

If you are in your twenties . . . If you have a degree in English, journalism, or something similar, now is a good time to apply for jobs as an editorial assistant or copyeditor while also honing skills by working for a local paper or something similar.

If you are in your thirties or forties . . . You should use skills and knowledge accrued in your current job to target an aspect of editing. Even if you're not working, but have a strong knowledge of fashion, say, you can use that knowledge to structure a résumé to send to a fashion-oriented magazine.

If you are in your fifties . . . If you are a specialist or otherwise distinguished in your field, you will be an ideal candidate as an editor for a targeted publication or publishing house. A stockbroker with good language skills can secure a position with a business magazine. A lawyer with writing prowess can edit a law journal. An auto mechanic who is word-wise can help shape a glossy on motor vehicles.

If you are over sixty . . . You probably want to aim at a smaller, slower-paced publication where your skills and knowledge will be prized and

your abilities to handle a lot of different tasks will go far in your new capacity. Again, find the type of publishing that interests you most—that will be the most rewarding path to pursue. You might consider editing material regarding a hobby that you enjoy. There are certainly many magazines, books, and guides on fly fishing, golf, coin-collecting, rocket building, music, art, and more.

Further Resources

Professional Editors' Network (PEN) A forum for self-employed and salaried professionals who work as editors, writers, proofreaders, and indexers to discuss the craft and job information. You can market your services and look for opportunities. http://www.pensite.org

Bay Area Editors' Forum An association of in-house and freelance editors from a range of publishing settings. Members edit every kind of material. A number are from outside California, although most are local. There are meetings to discuss the craft, you can post your information on the site, and there are job listings. http://www.editorsforum.org

***The Deluxe Transitive Vampire: A Handbook of Grammar for the Innocent, the Eager and the Doomed* by Karen Elizabeth Gordon** A useful style book done with twisted humor and Gothic illustrations. Very handy for copyeditors who are a little rusty and need a break from the usual sort of style books. Available online via Amazon and at all major bookstores.

Musician/Music Supervisor

Musician/Music Supervisor

Career Compasses

Guide yourself into your music career.

Relevant Knowledge of a wide range of music, musical styles, and instruments (30%)

Caring about all aspects of music and music history, as well as current trends (25%)

Communication Skills to put over ideas and work with either other musicians/performers or producers and directors to select ideal music for a project (25%)

Ability to Manage Stress both on the job and during the inevitable periods of unemployment (20%)

Destination: Musician/Music Supervisor

Although most people think most musical careers mean being a member of a band or an orchestra, there are many other facets to working in and with music. Opportunities are far-ranging for someone talented and innovative. Music is used in all aspects of entertainment, including film, television, video, theater, and radio programs. People with musical knowledge are tapped as consultants to select music in everything from commercials to theme tunes to film scores. Just as it is never to late to

pull together a band and start touring, it is never too late to forge a career using your musical expertise to improve someone else's art.

Musicians, whether playing for singers in a studio or as part of an orchestra or a rock band, almost all begin their study at an early age. The competition for any sort of music job is fierce, and those who can play a number of instruments and are proficient in a wide range of styles are the most likely to get jobs and build a career.

Serious musicians or musical artists spend a lot of time working on their craft. Even those who are successful still spend hours practicing, composing, and rehearsing. A busy musician might perform in a symphony orchestra, rock group, or jazz combo, all in the space of a week. That all may be in addition to recording music for a film or commercial. Schedules can be quite erratic, ranging from periods of unemployment to long nights and weekends spent working. Many musicians supplement their income by teaching, which can also take up a lot of time.

Essential Gear

CD library. Performer or supervisor, you are seriously expected to know your stuff, and you should listen to as much music as you can when you are not making it. With iTunes and iPods, you certainly have no excuse not to be up on everything that is going on in the music world.

Other jobs involving music include those of music directors and conductors. They conduct, direct, plan, and lead performances by orchestras, choirs, or glee clubs. Duties include auditioning and hiring performers, selecting music, and overseeing rehearsals. Music arrangers and orchestrators transcribe and adapt scores for performance. They determine tempo, volume, and choice of instruments.

Music supervisors may not have much musical training, although it certainly helps. Their job is to review and select music for film and television shows. They meet with directors, producers, and composers to discuss possibilities and make recommendations. While some supervisors focus solely on licensing deals, budgets, and contracts, most are very involved in the creative process and come to the job having a great knowledge of and passion for music in all forms.

An important aspect of a supervisor's creativity is his or her ability to provide the perfect music with virtually no budget. Most films and shows do not have much money for that aspect of post-production, and rights can be expensive. However, the right music will establish mood

and enhance the story, whereas the wrong music will be detrimental to the project. Thus, a music supervisor should be able to suggest excellent alternatives when the original choice is not available, but also, he or she should have the negotiating skills to discuss fee reductions with artists. Sometimes, an artist will like a project so much, he or she will reduce or even waive their fee and allow the music to be used.

Popular music supervisors will work on a number of projects at the same time, so they must be very well-organized and able to think about very different kinds of art and music simultaneously. It can be difficult to get your foot in the door as a music supervisor, but the best way is to work as an intern or assistant to an established supervisor. You can also offer your services on student films, community plays, local productions like educational films and commercials, and radio programs. Some music supervisors come to the job having hosted their own musical program on the radio. While fewer stations allow for this level of creativity, college and local NPR stations still have space for innovative DJs to host their own shows and choose their own playlists. This experience can be a useful way to get noticed by the film and television industry.

Essential Gear

Practice room. If you are not in school or in a full-time musical job, you must designate your own space for daily practice. That may be difficult in a small home with a family, but even if it is just a corner of a room, you should claim it for your own and find a way to make it comfortable and practical to work in so that you can find no excuse for not keeping your skills as sharp as your high notes.

Musicians predominately work at night and on weekends. Members of symphony orchestras, or those employed by production companies, enjoy a long-term contract, steady work, set hours, and less travel. Hours are regular, even for rehearsals, and the performance schedule is not overly grueling. Musicians in bands, or those who play in nightclubs or for recitals, will travel far more frequently and may endure long periods of unemployment.

There is a very old joke that pertains to musicians. "Question: How do I get to Carnegie Hall? Answer: Practice!" Carnegie Hall, of course, is the magnificent symphony space in New York City where the best musicians give concerts. Even if you do not play the sort of music that will be scheduled at Carnegie Hall (they do not tend to book punk bands, for example), the theory behind the joke remains the same. If a musician is

to be successful, he or she must practice, practice, practice. While a very few musicians may have just picked up a guitar one day and were rock stars the next day, the reality is most musicians begin playing music as children and continue to take classes for many years. They learn to play with others in school or community bands, or even just by putting together a group on their own. Many musicians offer accompaniment to singers or to school musicals. Good musicians understand that they never stop learning, even when on the job. That is the theory behind the jam session—it is a way for musicians to experiment together, collaborate, and discover new aspects to their sound and technique, while also having a great time and hopefully entertaining others.

Musicians interested in playing in symphony orchestras gain training at conservatories, for which they must audition, or in college or university programs. These schools teach music theory, music interpretation, composition, conducting, and performance technique. Those interested in becoming music directors, conductors, or arrangers will need advanced training in these subjects and a great deal of on-the-job experience.

As with any job in the arts, people who work in music must love what they do. Opportunities for full-time employment are difficult to obtain and shrinking. Changes in the music industry and consumer purchasing make it harder for bands to earn good money. However, you can still make a living doing what you love, and that love will make the work wonderful.

You Are Here

Do you have the noteworthy skills to make it in music?

Are you knowledgeable about a broad range of music? For both musicians and music supervisors, this is paramount. Gregorian chants, medieval canticles, Bach, jazz, swing, musical theater, rock, punk, and hip-hop—you do not have to know them all, but the more you know, the better a position you will be in to garner interest and secure work. You may be a rock devotee, only interested in forming your own band and playing on your own terms, which is great, but your music will be richer by being informed on other styles. For a musician looking for studio work, the ability to speak intelligently about a range of styles while waxing eloquent about your own favorite is at least going to get you a callback.

Can you play a variety of instruments? You do not have to be a one-man band, but versatility makes studio musicians more marketable. Unfortunately, part of this is to cut costs—it is cheaper to hire someone who plays the piano, guitar, and bass, rather than three musicians. On the other hand, learning multiple instruments improves your overall musicianship.

Do you have stage presence and comfort? Obviously, this is only necessary for a small range of performing musicians, but it is still vital. Furthermore, you never know when you might be called upon to play before an audience. A singer may like a studio accompanist so much, he or she asks the accompanist to join a performance. Anyone in a band must, of course, be a strong stage performer, as well as an accomplished musician. There is even an art to playing well on stage when a member of a large symphony orchestra. Some musicians make whole careers playing only in studios, but the best can do it all.

Navigating the Terrain

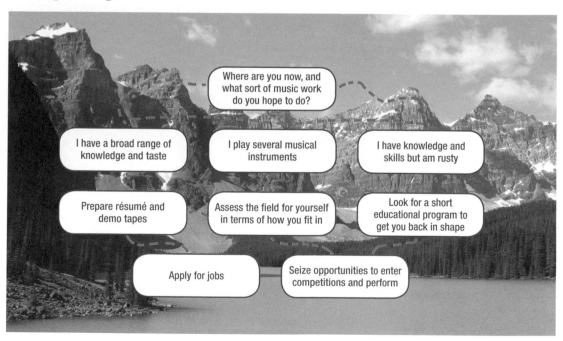

Where are you now, and what sort of music work do you hope to do?

I have a broad range of knowledge and taste

I play several musical instruments

I have knowledge and skills but am rusty

Prepare résumé and demo tapes

Assess the field for yourself in terms of how you fit in

Look for a short educational program to get you back in shape

Apply for jobs

Seize opportunities to enter competitions and perform

Organizing Your Expedition

Compose yourself for a journey into the world of music.

Be available. People always want to hire musicians for events like weddings, anniversary parties, and bar/bat mitzvahs. These sorts of events can be an excellent means of honing your performance skills. In areas both large and small, work like this is often obtained via word of mouth, so if you are well-liked, you can work fairly steadily. You will make a base salary and will usually be given a tip, plus a free meal. While you may not get to be creative with what you play, you should still make yourself available for this sort of work. When starting out, you may have to cut your rate, or even volunteer, but do not let that hinder you. You also never know who might be at the event. A young performer was offered a film role when Steven Spielberg was at a bar mitzvah he attended. A solo artist should make himself or herself available to play piano at better restaurants, houses of worship, and local dance classes. These can all be good ways to make a little money while improving your skills and at least adding to your résumé, if not actually making contacts.

Keep your mind and ears open. Although the music he made was nothing like what he heard growing up, Paul McCartney has often said he learned a lot just by listening. You may have originally pursued one kind of music, not seen any success, and given up. Opening yourself to other musical possibilities may surprise you with satisfaction and employment. After her work in the film *Chicago*, rapper and hip-hop star Queen Latifah was inspired to record an album of standards. Serious artists do not need reminding that inspiration can come from anywhere, but it is easy to get wrapped up in something else and lose sight of possibilities. Likewise, the best music supervisors stay popular because they pay such close attention to new and old music. Cutting edge television shows like *Buffy the Vampire Slayer* and *Scrubs* incorporated the music of new or cult bands, finding songs that added extra layers to pivotal moments in the programs. These moments were created by music supervisors paying attention to what was emerging anywhere and everywhere in the music scene.

Maintain your discipline. When a musician dedicates time to seeking employment, maintaining that all-important discipline can be difficult.

Stories from the Field

Liza Richardson
Music supervisor
Dallas, Texas

One of Hollywood's most popular music supervisors, Phoenix native Liza Richardson started off doing a range of other things before finding her calling. She initially focused on dance and drama in high school and college, leading her to musical theater and then to a volunteer job at a tiny Texas community radio station. Here, she enjoyed the freedom to go through records and play exactly what she liked. Listeners liked it, too. When Chris Douridas, DJ for *Morning Becomes Eclectic*, a popular show on the Los Angeles NPR station KCRW read an article about her, he offered her a show on KERA in Dallas. Douridas later became KCRW's music director and Richardson was his first hire.

The always-eclectic Richardson started off hosting a poetry show that blended spoken word and music. As she continued to explore possibilities in radio programs, she caught the attention of Mark Pellington, a music video expert at MTV who invited her to act as music consultant for a PBS program, *The United States of Poetry*. Excited by the work, she went on to supervise the music for two Pellington-directed films: *Arlington Road* and *The Mothman Prophecies*. Her rise as an in-demand music supervisor coincided with the increasing popularity of her

The business side of music can be extremely draining. Not only looking for work, but traveling from job to job and then playing long nights and having to travel the next day takes a heavy toll. You need stamina both on and offstage, and strength to manage the periods of unemployment. You also need to build up a tolerance for rejection, because even the best musicians will be passed over at auditions. In the midst of all this, you must continually work at your craft. Daily practice is the only route to strong, consistent performances.

Learn grace under fire. Conservatories and rehearsal halls are controlled environments. Onstage, however, anything can happen. Strings on guitars or violins can break, reeds can split, sound equipment can

various programs on KCRW. She was soon being tapped for jobs ranging from independent to major films, television shows, and commercials. The soundtrack she compiled for the noteworthy film *Y Tú Mama También* was nominated for a Grammy award. The various music supervision work she has done on advertising campaigns, such as those for the Mini Cooper and the Apple iPod, have also been given recognition and awards by top magazines.

Richardson's wide-ranging and consummate good taste landed her a plum and unexpected gig. She was chosen as the first-ever DJ to DJ the Academy Awards for the 2006 ceremony. She admitted to being nervous about the assignment, although her warm humor prevailed. As she told the *New York Times*: My job is to keep the mood upbeat and to keep everyone from wandering off to the bar during commercials. but my personal goal is to get Forest Whitaker to look up and give me a thumbs up.

In addition to her busy Hollywood work and regular morning surfing, Richardson still hosts a music show at KCRW—the very popular *The Drop*, on which she plays underground and limited vinyl releases. She describes the music as ephemeral, going on to say, "If I don't do my research for two weeks, I'm going to miss some records that I may never be able to get again." The occasional miss does not seem to create any problems for the constantly evolving artist.

blow, or someone may miss a cue or a note. Handling a situation with aplomb and professionalism pays off.

Landmarks

If you are in your twenties . . . If you have not been to a conservatory or accredited music education program, you should try applying for something now. In school, you get a strong, wide-ranging grounding in all aspects of your chosen musical path, have access to competitions and performance opportunities, and make contacts. Even just a two-year part-time program can help, during which you should try to have a music-related job.

If you are in your thirties or forties . . . If you have a strong knowledge of music and some involvement in the music industry, you are in an ideal position to seek work as a music supervisor. People want to hire someone whom they perceive as having a tremendous breadth of knowledge. Employers often want a music pro who pays close attention to the current music scene, popular and otherwise. Look for assistant jobs while volunteering for music supervision on small films and television shows.

If you are in your fifties . . . Whatever field of music you are looking to pursue, you should probably take a few classes to get back in good musical shape. Start looking for networking opportunities by attending performances and trade shows from those in the music industry.

If you are over sixty . . . Plenty of musicians continue to work after grandchildren, the best examples perhaps being the Rolling Stones. Depending on what you want to do, you should look for small venues to start. If you want to perform, post a video of yourself performing on YouTube—many people have quickly gained attention and popularity doing just that.

Further Resources

The American Federation of Musicians A membership organization created to protect and assist musicians in all aspects of the musical business. Most professional musicians belong to a chapter. The site offers various resources as well as contact information. http://www.afm.org

UCLA Extension This popular continuing education program occasionally offers a class in music supervision. If you are not based in or near Los Angeles, you may be able to take the course online. http://www.uclaextension.edu

The Music Media Entertainment Group A comprehensive Web site geared to assist aspiring musicians by providing an online community that nurtures and supports them. Includes many articles and informational resources. http://www.musicmediaentertainmentgroup.com

Graphic/Fine Artist

Graphic/Fine Artist

Career Compasses

Guide yourself towards a career as an artist.

Relevant Knowledge of art history, your own field of focus, and all aspects of art creation (40%)

Caring about doing top-notch work, whether pursuing your own art or under contract to fulfill someone else's vision (30%)

Communication Skills to work with your colleagues and to create art that says exactly what you intend (20%)

Ability to Manage Stress to work under tight deadlines and often have to change something at the last minute (10%)

Destination: Graphic/Fine Artist

Whether in *La Bohéme, Sunday in the Park With George,* or any number of similar works, the common perception of the professional artist is one of a devoted, but starving, individual. As the song says, "art isn't easy," but if it is your true love, it is worth all the hard work and struggle. More than 60 percent of artists are self-employed, and competition for work is very intense. Although today's artists may not be starving, they have to be

prepared for lean times. Inventive artists, however, can find many paying outlets if they have open minds and a good business sense.

Modern artists tend to fall into one of four categories: art directors, craft artists, fine artists, and multimedia artists. Some fit into more than one category. You may also start as one sort of artist and make a lateral move into a different arena as opportunity arises. All artists must be open to all possibilities.

Art directors usually work for magazines, advertising agencies, or publishing houses. The day-to-day nature of the work varies depending on the workplace. In essence, an art director designs the concept and look of a piece and reviews its content, determining how to make it the most visually arresting, appealing, and yet logical and organized. Art directors working for film studios designing theatrical posters or DVD covers, for example, must develop an enticing image that gives potential customers an idea of what the film is about. The animated hit *Ratatouille* accomplished this well by showing Remy, the rat star of the film, clutching a piece of cheese and pinned against a wall as a barrage of kitchen equipment came hurtling his way. Combined with the tagline "He's dying to become a chef," the poster showed audiences that the film would be about a rat interested in gourmet food—a funny enough concept to draw in even those who fear rats or are apathetic about food stories. An art director combines color, fonts, and images to enhance advertisements. The poster for the film version of Stephen Sondheim's *Sweeney Todd* shows a terrifying, furious Johnny Depp against a swirling blood-red background with suitable creepy lettering to boost the chill and thrill.

Craft artists use materials like fabrics, wood, glass, metal, and ceramics to create objects either to be sold at fairs, studios, or specialized gift shops. Such work is also often displayed in galleries and museums housing contemporary art. Many of these often employ some use of fine art as well, such as drawing or painting.

For the average person, when they think of "art," it is typically fine art that comes to mind. From Vermeer to Lichtenstein, images on a canvas that are usually in a museum constitute fine art. Art can sell very well in galleries, and commercial institutions often commission work from an artist. Most of today's fine artists, like Van Gogh and Seurat before them, have to supplement their income. They can do so in an art-related job such as working in museums or galleries, teaching, consulting, or critiquing.

More paid work is available in illustrating because it translates well to commercial art. Books, magazines, greeting cards, and calendars all employ the skills of top-notch illustrators. The explosion of graphic novels and comics has also provided graphic artists with creative opportunities. Increasingly, illustrations are created digitally, which can allow artists to segue into animation and other media work.

Combining a knack for visuals and a sense of humor can lead to paying work. Fans of *The Daily Show with Jon Stewart* and *The Colbert Report* know that one ingredient to the shows' brilliance are their clever uses of graphics as part of their "news" clips and stories. A more traditional route to the world of humor and art is through cartooning, especially the drawing of comic strips. A comic strip artist combines written and visual storytelling skills to present a form of art that is distinctive not only in look and style, but also in its ongoing appeal. While commercially popular with both children and adults, comics are also recognized as a legitimate art form and presented as such in museum retrospectives. The work requires immense speed and style. The best artists have a strong background in and knowledge of art history, which applies to their work. One of the modern classics, *Calvin and Hobbes*, drawn by Bill Watterson, used watercolors and styles reminiscent of Lichtenstein or the comic strip pioneer George Herriman. *Mutts*, drawn by Patrick McDonnell, often references famous art ranging from paintings to advertisements. Both strips are noted for their excellent, expressive artwork, strong characters, and powerful storytelling. If you have such combined talents, you might try to place a comic in a school or local paper. Garry Trudeau's *Doonesbury* started as a college comic strip.

Cartoonists with sharp senses of humor and an avid interest in politics can work for newspapers as political cartoonists. While an overall decline in newspaper readership has meant fewer opportunities for political cartoonists, aspiring artists should take inspiration from the experience of such notables as Norman Rockwell and Dr. Seuss, who began as political artists.

Essential Gear

Portfolio. For whatever sort of work you want to do, you will need to have examples of your best work gathered into a portfolio that shows it off to its strongest advantage. Take your time planning your portfolio. Show it to working artists and ask their opinions and advice. Be sure it shows the range of your capabilities.

A scientific background can also lend itself to a career as an artist. Good illustrators are always needed in medicine and science for textbooks, journals, and visuals used for education. They work either digitally or by hand drawing anything from anatomy to detailed aspects of surgical procedures to molecular structures and more.

Multimedia artists bring together hand drawings and digital renditions to create work used in film and video, advertising, computer games, and Web site designs. They might also draw storyboards, which are sketched breakdowns of scenes used for film, television, videos, and commercials. Storyboards help directors and production designers plan shoots. Increasingly, multimedia artists need to be skilled at rendering 3-D images with the appropriate computer software so that their images are as realistic as possible.

No matter how talented you are, becoming a paid artist still involves a lot of passion, dedication, and hard work. Mastering as many media as possible opens more doors. You may have to supplement your income, but a persistent artist will find that there are many opportunities for someone with skill and a distinctive vision.

You Are Here

Design your path into an artistic career.

Do you have a degree in art or some formal training? While going to art school or getting a degree in art at any four-year institution is not absolutely necessary, it is a sure way of building a strong foundation of experience and a skill set. Most artists begin making art when they are children, but talents need refinement to stand out in a strong field of competitors. Artists improve their work by gaining exposure and experience in areas they have not tried before. You may be a brilliant illustrator, but a few classes in sculpting, for example, can lend your work depth and reality. Also, classes in art history provide inspiration and a foundation of knowledge to draw upon. Finally, prospective employers usually want to see that you have at least a bachelor's degree in addition to your talent.

Do you have a lot of patience, and can you stay calm under pressure? Many artistic jobs demand working for long hours on very detailed projects.

One of the artists for the film *Wallace & Gromit: The Curse of the Were-Rabbit*, described how she spent days building hundreds of plasticine bunnies, many of which had to have a slightly different facial expression. The work required endless focus and care, but she adored it. If you are working for an ad company or something similar, you must also churn out detailed work under tight deadlines, and expect a lot of last-minute corrections and additions.

Do you respond well to criticism? Art can be subjective, and while one client may love your work, another may not. Employers can ask for impossible changes. They may ask you to make colors more vivid or scrap your concept entirely and use their idea. You may disagree, but in the world of commercial art, you have to accept critiques and changes with calm, and address them as diplomatically as you can, while pushing for your own artistic goals.

Navigating the Terrain

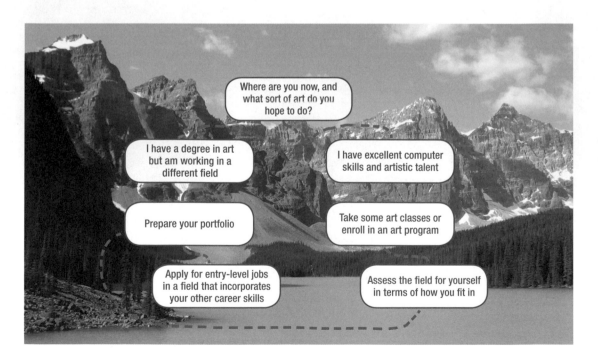

Where are you now, and what sort of art do you hope to do?

I have a degree in art but am working in a different field

I have excellent computer skills and artistic talent

Prepare your portfolio

Take some art classes or enroll in an art program

Apply for entry-level jobs in a field that incorporates your other career skills

Assess the field for yourself in terms of how you fit in

Organizing Your Expedition

Pack up your tool chest before you head on out.

Build your portfolio. You may have graduated top of your class from Chicago's famous Art Institute, but no one will think much of it unless you have a strong portfolio. Anyone can put their drawings or paintings or pictures of sculpture in a black zippered case, but showing your work at its absolute best is a skill all on its own. Especially in these days of digital art and 3-D renderings, you will often want to have your portfolio as a DVD, as well as in a black case. Your portfolio communicates your ideas and abilities, which is why many art schools offer short courses in assembling a portfolio. You should also talk to artists in your chosen field whose work you admire for advice on creating a winning portfolio.

Essential Gear

Tool kit. When you do get hired for an art job either in a studio or for a commercial venue where hand drawing or any other non-digital work will be done, you should bring your own kit of art tools and equipment. The job may have supplies for you, but you will look more serious and professional bringing your own gear.

Look for internships and volunteer opportunities. You will show real dedication and determination, as well as skill, range, and versatility, by volunteering your artistic skills. You might design the poster or program for a community theater production, or art used in a student film. You can draw cartoons for your local newspaper, design flyers for a political campaign, or create visuals for a short documentary or educational film. While real experience helps build a better portfolio, it also leads to all-important networking contacts and shows that you are serious about working in the field of graphic art. Plus, a job you do for free may lead to a paid opportunity later.

Take more classes. Even if you have a degree in art, if you have not been involved in the art world for more than five years, you will benefit from taking some refresher courses. The basics remain the same, but some aspects of the art world continue to change and you want to keep abreast of it. You can take courses specifically in comic book inking, for example, or 3-D rendering. Because digital art changes faster than any other format, computer design classes can always help. Someone with a

Notes from the Field
Ryder S. Booth
Freelance graphic designer
Palo Alto, California

Why did you get into design work?

It was a toss-up between being an illustrator and a graphic designer. Design won out because I rationalized that I could probably find more clients as a designer and have a better chance of making a living. It took a while to actually find my path, though. I started my first business right after high school thinking, "I know computers. I understand the programs. Design can't be that hard." I had to fail miserably in order to realize I didn't know what I was doing. It's definitely not as easy as you might think.

How did you learn the business?

I went to San Jose State in California after my first business imploded and actually got some schooling in the process of design. I learned about brand identity and doing lots of sketches or roughs before actually finalizing a project's look. I still feel like I never seem to get enough time on the front end of projects, where the actual creativity is involved. Usually I have time to do one or two conceptual ideas, and then it's off to the races to get the project done.

scientific or medical background can take classes specifically in medical illustration. Classes keep you "in shape" and can be another good way to make contacts. You could go from classroom to career far more quickly than you had imagined.

Enter competitions. One comparatively easy way to get your work seen and potentially land some paid work is by placing well in competitions. Even if you are not presently in art school, the art department in your local college should have some lists of contests you can enter. You can also find them online. Sites like ArtShow.com have lists of juried exhibitions and other such opportunities. Some contests have fees attached, but most are worth the cost as they add to your résumé, build your contacts, and widen your opportunities.

How did you establish a successful business?

One of the nice things about going to a design school is most programs place you in an internship. I started at a pretty cool firm, aside from my first experience with a temperamental boss. I was working on graphic design projects for an industrial design shop. My first project was working on a clothing line. Then I did some work for a local music store, and a variety of other businesses. This was also where I created my first Web site, which has turned out to the main focus of my career so far.

What are the keys to success in your career?

Keeping my plate full and having a large variety of projects keeps things interesting. This allows me to take a break from one project when I get stuck or lose my focus and then come back to it fresh. Also, the people that really succeed in graphic design are people who are able to communicate with their clients and cull what's important from those discussions into a project that fulfills the client's needs. It really is a subjective business though, so a lot of it is about sounding convincing and sure of yourself, and thus convincing your clients that your solution is a good one for them. Also, when you find good clients or employers, do what you can to keep them. They are your pot of gold, and finding them is the hard part. I've done my share of free projects—you do what you have to in building up a good client base.

Landmarks

If you are in your twenties . . . This is a good time to take a variety of art courses (unless you have just finished a degree in art) and determine which area you had best like to pursue. If you are interested in comics, for example, you are at an ideal age to develop your concepts and start building a body of work.

If you are in your thirties or forties . . . You should take some refresher art courses while building up a portfolio. Look for entry-level positions in larger organizations, or tailor your résumé to accommodate your current skills. If you are a quick sketcher and have a legal background, you may be a natural to work in a court or for a law firm, as they often use

illustrations in cases. If you are coming from a medical or scientific background, investigate opportunities in medical illustration.

If you are in your fifties . . . You should be sure your computer skills are strong. Even if you are looking to get work where you will not use computers, people will be impressed that you are as technologically savvy as a twenty-something.

If you are over sixty . . . It is all about the résumé, portfolio, and applying the skills you have accumulated over the years. In a less frantic environment, your excellent artwork combined with extensive knowledge will be viewed as a real benefit. While it is true that most paying art jobs, especially for those who are less immediately experienced in the field, go to younger applicants, your portfolio is what sells you. If you have a good one, combined with knowledge and a range of abilities, you can put yourself on the top of the list.

Further Resources

Graphic Artists Guild A national union of illustrators, designers, and other artists, providing a space for them to share stories, resources, and opportunities. Offers teleclasses, links, local chapters, and advocacy. http://www.gag.org

National Endowment for the Arts Although funding has been cut severely, artists can still apply for grants through the NEA. Artists should also research state and local arts councils. http://www.nea.gov

Juried On-Line Arts Festival JOLAF offers a forum, gallery, membership opportunities, and lists of educational opportunities, publications, festival information, and other useful links. http://www.jolaf.com

Stage Manager

Stage Manager

Career Compasses

Find your way to a job behind the scenes.

Relevant Knowledge of all aspects of theater, both behind the scenes and on stage, as well as union rules and health and safety guidelines (25%)

Caring about the show, the cast, the crew, and the many details involved in making it all work seamlessly every performance (25%)

Organizational Skills to keep everything running on time, all personnel doing what needs to be done, and bearing hundreds of tiny details in mind (25%)

Ability to Manage Stress, both your own and that of the cast and crew, as you all work together to tackle problems and put on a strong show (25%)

Destination: Stage Manager

The stage manager is one of the busiest people in a theater and has as much responsibility as the cast to make sure that the show goes on and goes well. In essence, it is the job of the stage manager to see that all live performances run smoothly.

On a large production, the manager leads a team, usually including a deputy manager and one or two assistant stage managers. However,

many smaller productions, even including off-Broadway, only have a single manager, whose duties include organizing the practical and technical aspects of both rehearsals and performances; assuring that cast and crew arrive on time; working with the costume, set design, sound, and lighting crew to plan the look of all these crucial elements; managing budgets; organizing props and sometimes set dressing; liaising with theater staff; supervising the loading in and out of sets before the show and when the run ends; cueing actors to go on; and cueing the crew for sound and lighting.

During the show, the duty of cueing (known as "calling the show") is paramount and a manager must be able to pay attention to many elements at the same time. He or she maintains the prompt book, also called the "bible" or "call book," of the script, The prompt book not only has the text of the play, but also notes the actors' positions on stage, as well as props, lighting, and sound (including music) for each scene. Keeping a thorough prompt book can be especially challenging when working on a musical, particularly because the modern design of many theaters means that the actors cannot see the music conductor, and the conductor can only see them via monitor. The stage manager is the liaison between the two, making sure that all the cues are correct and on time.

Concerts also require stage managers, and they have nearly as much work to do monitoring scenery and sound equipment. The famous scene in the comedy classic *This Is Spinal Tap*, wherein bassist Derek Smalls (Harry Shearer) is trapped inside his plastic pod, is actually an example of a failing on the part of the stage manager. It was the stage manager's job to test the pods several times before the concert began to be sure they were all working properly.

To be a good stage manager, you have to think fast on your feet, remain calm, and be prepared for any disasters. Even long-running, well-oiled shows in the biggest Broadway houses will have problems, and most of the time the stage manager solves them without affecting the show. Sometimes, however, an interruption is unavoidable. Experienced actors can have a bad night and suddenly forget a line. The manager must give it to them as clearly and yet quietly as possible. And you must expect the unexpected—over a year into the run of the Broadway hit *Wicked*, a computer malfunction resulted in a trap door opening at the

wrong time. Idina Menzel, playing Elphaba, fell and injured her ribs. The stage manager had only seconds to see that the curtain was dropped, the house lights brought up, and a doctor was called. The stage manager determined if the show could continue and what to communicate to the audience. Because the understudy had to put on the green paint, the show couldn't start again until 40 minutes later. The manager had to stay calm and clear-headed, reassure the other actors, and apologize to the audience for the delay.

A stage manager should be highly knowledgeable about acting and directing, and have some experience in both. For long-running shows, when a cast member is replaced, the stage manager is often responsible for rehearsing the new actor. That daily practice typically demands unusually long hours to get the actor ready for the role. When a Broadway hit goes on tour, the stage manager acts as director for the production. A stage manager is also responsible for assessing everyone's performances during a long run, making sure that no one is getting stale.

Essential Gear

An all-black work wardrobe. There is no uniform for stage managing, but if you are working in theater, you must wear all black. The audience should never be able to notice you in the wings. A new assistant stage manager on a major show had to be reminded that all black means all black. Because he wore white socks under his jeans, the audience and the actors were distracted by a flash of white whenever he sat down. You are meant to perform miracles while remaining virtually invisible, so dress accordingly.

To land a first job, most budding stage managers have a degree in theater and some practical experience. Many actors and behind-the-scenes workers move into stage management. You can gain experience as a student or by volunteering for community productions. Although it is good to take classes in management and theater technology, much of the job is learned by doing it. Since most small venues have no budget for an assistant, you will have to work for free initially, but it is a great way to develop skills and contacts.

Professional stage managers must also have excellent organization, communication, people and leadership skills, as well as flexibility, multitasking ability, infinite patience, punctuality, and some computer and budget-management smarts. Above all, those who thrive have an

undying love of theater and live performance. The work is very hard and often does not pay well, although professional stage managers have a strong union. The hours are long toiling side by side with the director and all the crew, putting in time on afternoons, evenings, and weekends during performances. You are expected to be the first person in and the last one out, assuring that everyone has completed their work, all is in order for the next day, and the theater is empty. If a show goes on tour, you go along too. You also have to be prepared for working conditions that involve spending hours in hot, dusty, cramped, and dark spaces backstage. You are looked to as friend, nurse, caretaker, drill sergeant, and cheerleader. If you love theater and are devoted to the work and the process, all this is just part of the fun.

You Are Here

Determine your abilities to manage productions.

Do you know a lot about the technicalities of theater from backstage to onstage? Those with a background in acting typically know the ins and outs of a theatrical production. Actors often have a knowledge of lighting, sound, set design, costume, and the multitude of elements that go into this career. You also need to know the appropriate terms and abbreviations. For example, a lighting cue can be "LX Q 20, stand by" and lighting operator will answer "standing," at which point the manager will say "LX Q 20, go."

Are you obsessive about detail and good at multitasking? You cannot be dreamy or star-struck in this job. A stage manager has the entire production to manage, and even if the show is a solo turn, every detail requires constant attention before, during, and after the show. You have to pay attention to both your prompt book and the performance at all times. Is an actress standing slightly off from where a piece of scenery is scheduled to drop? You must be able to signal this to her quickly and discreetly. You may also have to signal the stagehand whose job it is to drop the scenery. You also maintain lists of phone numbers and pertinent information.

Do you have a good attitude and unflagging energy? Different and sometimes difficult temperaments clash in the theater, but the stage manager is the one person who has to remain level-headed. You are the one who liaises with everyone: cast, crew, production staff, theater staff, and you must be able to work well with all of them. Because so much of a production rests on your shoulders, you have to be like the Energizer bunny—going and going and going.

Navigating the Terrain

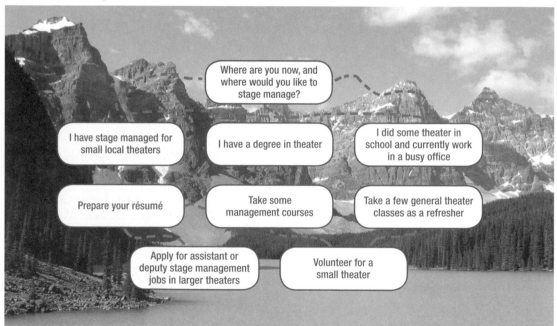

Where are you now, and where would you like to stage manage?

I have stage managed for small local theaters

I have a degree in theater

I did some theater in school and currently work in a busy office

Prepare your résumé

Take some management courses

Take a few general theater classes as a refresher

Apply for assistant or deputy stage management jobs in larger theaters

Volunteer for a small theater

Organizing Your Expedition

Take charge of future life managing the stage.

Take some classes in health and safety, as well as production management. Live performances will have accidents big and small, so if you know some basic first aid, or even CPR, you become much more valuable. Professional theaters adhere to strict safety rules, but you should know them all yourself and have a strong general understanding of good safety procedures on the job. You want to build a reputation as

a stickler for safety as much as performance details, so that producers know that bringing you on means their insurance rates are likely to remain stable.

Improve your construction and painting abilities. In a smaller venue, or if you are an assistant stage manager, you may be called on to assist with aspects of set building and painting. This can be rare, but prospective employers will be pleased to know that you can perform such tasks if needed. Furthermore, if you have some hands-on experience in construction, you can communicate more effectively with the design team.

Seek out unexpected opportunities. If you are not currently in theater school or no performance venue is in your area, look for other ways to gain experience. Resorts, cruise ships, corporate events, theme parks, and summer camps all stage productions of one sort or another. While you gain stage management experience at these venues, you earn points towards entering the union and make valuable contacts.

Essential Gear

Blue pencils, highlighters, and other organizational tools. You keep track of the show's bible, your list of contact numbers for the cast and crew, a schedule, and any number of other papers. However you like to keep things organized, you have to devise your system and stick to it. You need a system to track and make notes—blue pencils and highlighter can help.

Get to know the locals. Because so much of stage management work can be freelance or contract based, securing a job often depends on good word of mouth and networking. This is one of the many reasons why volunteering for work in a well-regarded house can be so beneficial. Not only do you learn a lot, you can meet people who may hire you when the next paying job comes along. Other ways to meet people and find out about job opportunities if you are not in the union is by joining organizations like the online-based Stage Managers Network (http://www.smnetwork.org). Here you will find a number of active discussion forums with announcements, anecdotes, advice, and opportunities. There is also a list of useful links ranging from safety guides to networking sites maintained by stage managers. If you see a show that you enjoy, try tracking down the manager and ask for an informational interview. Stage managers have dozens of humorous and horrible stories that they love to share, and you can learn a lot from them.

Notes from the Field

Christy English
Stage manager, Theatre IV
Richmond, Virginia

Before working as a stage manager, I was an actor. I worked profes-sionally as a stage manager at Theatre IV, a theater in Richmond, Virginia, which was largely devoted to children's theater, but which also had an adult season doing straight plays.

Why did you change your career?

I desired a little more stability in my creative work. While being a stage manager is unstable, as most theater jobs are, it had more stability than acting. As a stage manager, I could line up my jobs months in advance, which allowed me to plan farther into the future. While I was never able to fully support myself with my stage management work, I had enough steady employment with Theatre IV that I was able to keep another part-time or full-time job during the day, leaving my evenings and weekends for rehearsals and performances.

How did you make the transition?

I moved to Richmond after finishing college at Duke University to work on an independent film, both as an actor and as the first assistant direc-tor. Once that film was done, I decided to continue to live in Richmond where I had met other actors and theater people. I learned of Theatre IV from fellow actors, and I sent the theater my résumé. I submitted

Learn union requirements. On a professional show, everyone is in a union and each union has different rules that must be strictly adhered to. By the time you are eligible for such work, you should know the rules pertaining to the stagehands, actors, and musicians' unions. You your-self will either be a member of the Actors' Equity Association and/or the American Guild of Musical Artists, each with strict rules governing your work. The union works hard to protect you, but at the same time, expects you to hold fast to its rules and requirements.

this résumé, comprised of stage management work and technical theater work that I had done in college, while Theatre IV was still putting together their fall season. After a brief interview, we agreed to work together for the first production of their fall season, Johnny Appleseed.

What are the keys to success in your career?

To be a good stage manager, you have to be organized. Working with the director, I would keep the production on track throughout the rehearsal process, keeping a script as well as a notebook on hand to record blocking and to give a line when an actor called for one. Once a show was in production, I kept a call book, and would call the show from the booth, giving both lighting cues and sound cues to the technicians while following the show line by line.

Another key to success as a stage manager is to be prepared for anything, because when working with actors in the theater, anything can happen. One day, when we were doing a production of Da, we had a middle of the week matinee. One of the actors forgot to show up. As stage manager, I called his home in an attempt to contact him, and kept everyone else calm while he was en route to the theater. Our call time was an hour before curtain, but that day our lead showed up five minutes before curtain was scheduled to go up. By keeping everyone calm and by keeping my head, I got the lead in makeup and on stage, and started the show only 10 minutes late. The audience never knew why we were delayed, and they enjoyed the show so much that they did not care.

Landmarks

If you are in your twenties . . . If you have a theater degree, seek out a variety of opportunities to give you the widest range of experience possible. This is the time when you should be amassing contacts and skills and talents that will help you work your way up the professional ladder as you gain more hands-on experience. You can also apply for full stage management jobs in smaller venues or touring productions.

If you are in your thirties or forties . . . If you have not been involved with the theater for a while but have other applicable experience, like managing a busy office, take a few theater classes to ease yourself back into that world. Then look for opportunities to work some evenings or weekends at a local theater learning the basics as you apply for assistant or deputy jobs in larger theaters or management jobs in smaller ones.

If you are in your fifties . . . If you are moving from a different job in theater, like acting, directing, or backstage work, you have the knowledge and contacts to land yourself at least a deputy position. However, you can make yourself an even more desirable candidate by doing some managing in a smaller venue first.

If you are over sixty . . . Smaller venues want someone they view as steady and comforting, and, however stereotypical it may be, someone who is in his or her sixties will seem like exactly that sort, rather than someone in their twenties. If you have experience organizing operations in a frantic setting and some theatrical knowledge, you will find yourself very welcome in the business.

Further Resources

The Stage Managers' Association A professional organization created by and for stage managers. Provides a network where managers can further educate themselves via the exchange of ideas and stories and seek to improve their work through discussion. http://www.stagemanagers.org

Stage Managers Do Make Coffee **by Carissa Dollar** A fun and comprehensive online handbook on day-to-day work as a stage manager. http://www.mts.net/~skirzyk/SMscoffee.htm

Stage Jobs Pro Lists jobs in the US, UK, Canada, and Australia. You can also post a profile so that employers can find you. It is free to join and there is an active forum and links. http://www.stagejobspro.com

Actor

Actor

Career Compasses

Find the path to a life in the spotlight.

Caring about the craft and your commitment to excellent work (30%)

Communication Skills to put your work across to an audience that may not be giving you its full attention, but if you do well, they might start (30%)

Ability to Manage Stress both on the job and during the often long stretches in between jobs (20%)

Relevant Knowledge of the craft and the business (20%)

Destination: Actor

Of all careers in the field of arts and entertainment, acting is one of the most visible and desirable. It is also one of the most difficult in which have any level of success. That said, if you are prepared to work hard and realistic about your chances for paid success or fame, you can enjoy an exciting and satisfying new career in a thrilling and inspiring environment. Many actors spend their whole careers only in dinner theater,

summer stock, cruise ships, or community theater. While they do not earn much money, they gain a lot of personal reward.

The three most common and popular media in which actors work are film, television, and theater. Actors also perform in radio, commercials, video, cabarets, theme parks, and "industrial" films made for training and educational purposes. Increasingly, actors are finding work in new media based on the Internet. This area is expected to grow rapidly in the next few years

While the most famous actors are all based in New York or Los Angeles, a far greater percentage of working actors are making livings throughout the country in local or regional television, theaters, or film production companies who make advertising, public relations, or other independent small-scale films.

Still, the bulk of working actors face long stretches of unemployment. Earnings are unpredictable and competition is fierce for even the lowest-paid jobs. Although it may be as long as a year before the next job comes along, an actor must still maintain his or her skills by taking classes and workshops. He or she must also maintain top physical condition, because a great deal of stamina, coordination, and breath control is required to work on a stage for two hours during a show, eight shows a week. Add the hot lights and possibly heavy costumes and it can be the equivalent of a daily marathon. Even in film and television, long hours can be spent under hot lights in heavy costumes and the work can be an immense physical drain for which an actor must always be prepared.

The work of acting is stimulating, rewarding, and can often be fun, but the environment is enormously stressful. Actors can spend months

Essential Gear

Résumé. If you are just starting out, forming a résumé can be difficult, but anything you have done, even if it is only college productions and background work, is acceptable to list as a credit. Since student filmmakers are always desperate for actors willing to work for free, agree to appear in a few short films to quickly give yourself credits. When you have few credits, make your résumé more interesting by noting where and with whom you have received training and what skills and tricks you have. Leave nothing out, whether it is ventriloquism, juggling, or acrobatic moves, because you never know what someone might be looking for. Depending on what your former career was, you should make note of that as well. If it is unusual, an agent or casting director may want to meet with you just out of curiosity, and if they like you, they may take a chance on you.

or even years between jobs. When they do land a job, the work hours are long and demand total commitment and concentration. Giving believable, three-dimensional life to a fictional character requires a depth of skill that must be studied over a period of years to do well. Delivering good performances is hard enough, but an actor must often attempt to do so under equally difficult conditions. It is never easy and things will always go wrong, and a successful stage actor must be able to improvise or ad lib when that happens. He or she has to remain fully committed, even if there is only one person in the audience.

Essential Gear

A demo reel. This is strictly for film and television actors, but it can be crucial. Sometimes, instead of being called in for an audition, you are asked to send a demo reel (nowadays a DVD) showing your best work. As soon as you do anything, from a student's short film to a local commercial to being an extra on a show where your face is fully captured on film, you must get a copy of those scenes and put them together on your demo reel. This is commonly done, and it is expected that you will request the footage.

Even working in film or television is stressful and arduous. When you land a job on a film, whether it is a big budget or no-budget piece, you will usually arrive at the set by 5 A.M., if not earlier, have makeup applied, and then wait for hours before your scene is ready to be filmed. A performance must be sustained as it is done over and over. Each time a scene is filmed is called a "take," and it may have to be done dozens of times before it is considered complete. The performance has to stay natural and strong, even though an actor may be at an awkward angle, under hot and bright lights, and the camera very near to the face. In this era of CGI, which can often be done on a low-budget work, an actor must often pour heart and soul into a dangling tennis ball that provides the sightlines for a character that will be added digitally in editing. Or he or she has to run for it or fight a battle with that same tennis ball in front of a green screen.

An actor on television, whether a series regular or a guest with one line, must do quality work at top speed, because an episode must be completed in very few days, giving little time for mistakes or poor work. Additionally, scripts tend to be revised frequently, often moments before a scene is filmed, so the actor must be able to memorize those new lines and deliver them perfectly.

Acting can involve a lot of time away from home. National tours provide jobs for both union and non-union actors, but they can last for months. Work on cruise ships and resorts will also mean a lot of travel. This can be fun, but hard if you have a family.

Not all actors are highly trained. Some have innate talent and intuition, as well as great luck, and can do good work without years of study. For most actors, training begins with the high school drama club or community theater group. From there, an actor may go into a conservatory, which is a rigorous training facility where students study all aspects of acting, including Shakespeare, singing, stage movement and dance, fighting, and dialect. Since competition for any work is so stiff, developing a large bag of tricks is helpful. Actors who speak more than one language can do a variety of accents. Those who play a musical instrument, do gymnastics, dance, sing, fence, or juggle are in a better position to secure a role than someone who is more limited.

Ultimately, you must have a deep passion for performing and a love for entertaining others. This, combined with patience and a commitment to the craft, can bring years of rich and rewarding work.

You Are Here

The journey to becoming an actor can begin almost anywhere.

Do you have passion, drive, and a burning desire to entertain others? The common stereotype of an actor is a selfish person who is constantly desperate for a spotlight and attention, but the truth is that all the best actors simply love to perform and will do so under any circumstances. It is not about the attention, it is about what they can give an audience. If you experience great joy when you have the opportunity to entertain, you know your instinct for acting is a good one worth following. That feeling of joy needs to be strong enough to sustain you between jobs and help you keep focused on what you care about most. If you are someone who can stay positive in the face of a lot of rejection because you believe in yourself and what you have to give, you have what it takes to go far.

Do you have a lot of performance skills and experience, and/or are you willing to enroll in a conservatory? If you acted in high school or

college, took dance or music classes, or have any other performance ability, like amateur comedy, you probably have a sense of your abilities and whether people enjoy you as a performer. You also have a sense of the amount of work involved in entertaining people while fully engaging your body and voice. No matter how much you think you already know, however, you should definitely sign up for classes. Not only are lessons useful in grounding you in both basics and more complex skills, but you will need a community of fellow struggling actors for encouragement and support. A class is the best place to begin to form those all-important ties.

Do you have very thick skin and are you good at handling criticism?
Acting can be considered the hardest and cruelest of all the jobs in the field of arts and entertainment. In any other profession, it is your work that is assessed with either praise or criticism. But an actor is judged on every aspect of his or her personal appearance, as well as talent and skill. It takes a unique strength and confidence to stand before a roomful of strangers who might tell you that you are not suited for a part.

Navigating the Terrain

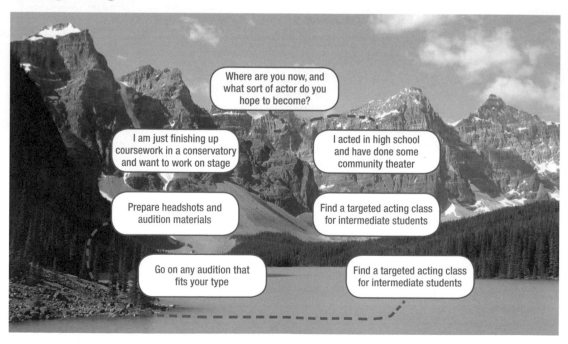

Where are you now, and what sort of actor do you hope to become?

I am just finishing up coursework in a conservatory and want to work on stage

I acted in high school and have done some community theater

Prepare headshots and audition materials

Find a targeted acting class for intermediate students

Go on any audition that fits your type

Find a targeted acting class for intermediate students

Organizing Your Expedition

Before you head for your first audition, be thoroughly prepared.

Have headshots taken. The headshot, a black-and-white photograph of your face at its best, can jumpstart your career. Good headshots are very expensive, but worth it if they impress casting directors and producers. Shop around for a good photographer. If you meet someone who has a particularly good headshot, ask where he or she had it done. You should also consult with several people as to the sort of look you want for your headshot. If you have a killer smile, be sure to show it, even if you think it is more sophisticated to look serious. If your natural look is wholesome "girl/boy next door," do not overdo the makeup. A quality photographer and makeup artist will be able to work with you to create a photo that pleases you and gets casting directors interested.

Essential Gear

Theater and movie tickets. As a struggling actor, you are poor, but sacrifice whatever you can in favor of going to see good performances. Watching good actors work is an acting class in itself. The same is true for watching bad acting, although that tends to be less fun. However, there is still much to be gained from it, and if you are going to be serious about this pursuit, you should be able to discuss actors in classes or auditions whose work you admire and understand what makes that work your inspiration. Both directors and other actors prefer to work with someone who is intelligent, thoughtful, and knows their local history.

Pack your suitcase with audition materials. Surprising though it may sound, you often have to audition even just to get into a good acting class. Teachers want to determine if you have talent worth developing and are as strong and fearless as you must be to succeed. Even if your first class does not require an audition, begin preparing monologues to use as audition pieces. To start, you want at least three: one comic, one dramatic, and one classic, usually Shakespeare. Shorter is always better, and a monologue that can be trimmed further for some auditions is most useful. You can find monologues published in any number of books related to acting. You should also prepare a few bars of at least two very different songs if you sing, and a short dance routine if you dance. Most of the time, you will be told what to read, sing, or dance, but you still want to have all your tools ready. And

Stories from the Field

John Mahoney
Actor
New York, New York

Now famous as the Tony-winning, Emmy-nominated stage actor and star of *Frasier*, as well as noted feature player in a number of films, John Mahoney only began his career as an actor when he was 40, although he had studied acting for a short while as a teenager.

Born in England, Mahoney emigrated to the U.S. on a visit to his war-bride sister. He joined the army so as to become a citizen and later taught college English and worked as an editor for a medical journal in Chicago. Disillusioned with his career, Mahoney found himself drawn back to his first love and started taking acting classes at the St. Nicholas Theater. He made the momentous decision to quit his day job and pursue acting full time. Fellow actor and student John Malkovich encouraged him to join the renowned Steppenwolf Theatre Company.

do not be afraid to shake things up. An actor recently landed the lead in a small production of *Urinetown* by performing the St. Crispin's Day speech from *Henry V*, realizing that the characters were both rallying troops to fight a seemingly hopeless battle. The unexpected speech that shows you think creatively about your work can stand out.

Explore unexpected possibilities. You can learn skills and sometimes even gain credits towards joining one of the actors' unions (Equity for stage, Screen Actors Guild for film and television) by securing acting work in a theme park, cruise line, or summer stock theater. You will still have to audition, but it is understood that the actors seeking work in this arena will be amateurs, no matter what their age, and it is a forgiving environment. It's not a place where you can expect to be discovered, but if you focus on the work at hand and the process, you can learn a lot. The work can be hard and the pay low, but the opportunity to gain experience is priceless.

The actor's first task is to master the audition.

He did and soon found himself working regularly. He won the Clarence Derwent Award for Most Promising Male Newcomer. A few years later, he won the Tony Award for Best Featured Actor in a Play for his role in *The House of Blue Leaves*.

Mahoney had several small roles in films through the 1980s and early 1990s, including notable turns in the Oscar-winning *Moonstruck* and the teen favorite *Say Anything*. While he was certainly not famous, his fatherly look, gruff voice, and sweet smile lent themselves to a particular niche. He was the definitive "character actor." Mahoney's look, voice, and smile all landed him the role of Martin Crane, father to Frasier Crane on the hit television show that ran from 1993 to 2004, and the unassuming, relatively unknown character actor became a household name.

The income derived from the show has given Mahoney the comfort to focus almost exclusively on theater, which he considers his home. He is still a proud member of Steppenwolf and continues to act in their productions (he has appeared in over 20) and was recently seen on Broadway again in the Roundabout Theatre's revival of *Prelude to a Kiss*.

Read the local papers. In New York, the paper to read religiously is *Backstage*, which lists local auditions throughout the tri-state area, including auditions for national tours. Until you have an agent, this is how you find out about auditions. If you are not in Equity, you can usually still attend an open call, but the Equity members will get to audition first and time may run out before you are called. If you do get to audition and they like you, they can arrange for you to become a union member, which will make all the difference as you carry on. In Los Angeles, *Backstage West* and *DramaLogue* publish auditions for theater, film, and television. One note: Some ads will be hoaxes, and some will be for projects that are little more than pornography. If something looks at all suspicious, it probably is not worth your time.

Landmarks

If you are in your twenties . . . This is a great time to cultivate your education and craft. You should go on every casting call offered, just to gain

the experience. If you need to work, take a night job like bartending that should allow you time for lots of classes. Now is the time to stuff that bag of tricks as much as you can. It is also a great time to take risks, like getting involved with experimental theater and student films.

If you are in your thirties or forties . . . Getting a space at a conservatory can be ideal, as you will have structured classes and a great opportunity to make contacts and get involved with productions that might showcase your abilities to useful people. Attend every audition for someone in your age range. Even if you have little experience, you may have the talent and a look that will arouse interest and possibly secure you work more readily than the average good-looking twenty-something.

If you are in your fifties . . . Look for specialized workshop classes and seminars taught by well-known actors or drama teachers. Courses like this will be smaller and more comfortable environments in which to begin. The teacher is likely to be about your age and can advise you as to what sort of jobs you might be good for and how to pursue them.

If you are over sixty . . . If you have any ability, you might be surprised what is out there for you. Chances are, you are more relaxed and easygoing than those in their twenties and thus take to certain kinds of roles very naturally. In film and television especially, small roles are available for older actors with a distinct look, and directors tend to enjoy working with them because they know there will be no difficult temperaments to contend with. You are there to work, and they will respect you for it.

Further Resources

The New York Public Library for the Performing Arts They have an enormous archive of theatrical materials, including thousands of recorded performances going back several decades. Watching performances is a great way to augment your education, and it is free. http://www.nypl.org/research/lpa/lpa.html

Alice in Theaterland An excellent Web site full of casting information and links to agencies and casting directors, as well as tips on monologues,

discussion forums, and suggested reading.
http://www.aliceintheaterland.info

New York University Tisch School of the Arts One of the best drama schools in the country for more than 40 years, located in the city that provides a drama school in and of itself.
http://www.tisch.nyu.edu

Makeup Artist/Hair and Wig Stylist

Makeup Artist/Hair and Wig Stylist

Career Compasses

Make your way to a life onstage.

Relevant Knowledge of your art and the field in which you are working, as well as lighting, costume, and the other factors that affect your work (40%)

Caring about doing beautiful work in any capacity and for any size venue (25%)

Communication Skills to work well with the other members of the creative team and the model or performer for whom you are designing the makeup or hair (25%)

Mathematical Skills to understand and work within budgets (10%)

Destination: Makeup Artist/Hair and Wig Stylist

For many centuries, actors did not need makeup because they performed using masks. Wigmakers were busy, however, because the masks included elaborate wigs that helped define the character as much as the mask itself. Theater and film continue to use makeup, hairstyles, and wigs to enhance characters' appearances and tell the audience more about them through the use of visuals.

The job of devising makeup, wigs, and hairstyles is sometimes divided between two artists, or just given to one person. Someone who is equally adept at working with the face and the hair opens themselves to more employment possibilities. In addition to working for theater, makeup and hair stylists work in film, television, modeling, and photography. Many of these jobs pay very well, and artists who work in theater usually supplement their income by working in the modeling and photography worlds. The work is usually freelance, although many makeup artists either land full-time jobs on a television show, with a theatrical company, or develop relationships with photographers that lead to regular work. Likewise, they may be attached to an agency or production company.

Essential Gear

Portfolio. Being able to show off your abilities and creativity to a potential employer helps you no matter what level you are on, even if you are looking for an unpaid internship to start. You should ask for informational interviews with craftspeople in your area of interest and get their advice on the look and content of your portfolio. As much as you can do to sell yourself, that is what you have to do.

Most specialists working with makeup, hair, and wigs learn their trade at a theater school or school dedicated to these arts. However, this is also a profession one can learn as an intern or assistant and thus rise through the ranks.

Some makeup artists will specialize in a given area, such as fashion, theater, television, and film. As mentioned above, it can be useful to have more than one specialty to guarantee a wider range of regular work.

Fashion makeup, used for advertising photography and runway shows, tends to be highly stylized and thematic. It might be quirky or garish, but its overall aspiration is to make the model or actor look as attractive as possible, and thus better sell the product being advertised or shown.

Makeup for theater varies considerably, depending on the size of the theater, the lighting, and the costume and set design. This is all separate from stylized character makeup and prosthetics. Basic makeup for men and women is designed to highlight the faces so that they appear as distinct from the back row and yet not clown-like from the first row. Eyes and lips are well defined as are facial bones.

For high definition television, a new makeup arena, the challenge is to make a person's face look as flawless as possible under the extreme resolution that shows off even the tiniest flaws.

Special effects makeup, such as that perfected by multiple-Oscar winner Rick Baker, involves anything from fantasy makeup (as in the Lord of the Rings films) to blood and gore to prosthetics (fake noses or an extended chin, for example). Because the most elaborate uses of this makeup will involve plaster casting and other such craftwork, the artists who do it tend to specialize in this field and are at the forefront of developing new special effects techniques. Science fiction movies and television programs such as *Star Trek*, *Battlestar Galactica*, and *Buffy the Vampire Slayer* show how elaborate makeup can be. The growing popularity of crime dramas have spurred developments in forensics makeup in order to realistically depict victims' wounds.

Wigs tend to be used for theatrical productions more often than the performer's own hair, mostly, but not only, for period pieces. It can be far easier to wear a wig than style hair every evening. The design and styling of wigs is a difficult craft that can only be mastered with a lot of hard work and practice. For theater, a wig maker builds a wig with what is called a ventilated front and then crochets or hooks strands of hair into that fabric. This creates a more natural looking hairline than a store-bought wig does. Even smaller productions tailor wigs specifically to the hairlines of each performer, although oftentimes wigs that are already in the company's store room can be adjusted, rather than built from scratch. A good theatrical wig maker can buy long-haired wigs from any shop and restyle them for the theater.

The best wigs are made from human hair, although synthetics such as horsehair rayon or dynel are also commonly used. Human hair wigs tend to be preferred, however, because they can be styled using conventional equipment.

A wig stylist's work does not begin until the costume designer's sketches are complete. Then he or she works with those sketches to devise a hair concept. For period hair, a wig stylist studies paintings and photographs from the given era to assure a correct look.

While not all wig makers receive formal training at a theatrical school, they do tend to spend a number of years working with more experienced wig makers to learn their trade. Strict attention to detail, patience, and care are important attributes of excellent wig makers and stylists.

For both makeup and hair specialists, tact and good interpersonal skills are absolutely crucial for ongoing employment. Appearance can be a sensitive issue for a performer or model, and a good stylist understands

this and is warm and communicative with the performer, creating a safe and trusting space.

In the theater, a makeup and wig stylist generally only works during the rehearsal period, designing and preparing the makeup and wigs and instructing the actors in their use. Actors learn how to do makeup in drama school, so once a palette for a show is created, actors can apply their makeup themselves throughout the run. The exception will be for a show that requires extensive and complex makeup and hair.

Professionals hiring interns and assistants look for a high degree of enthusiasm in applicants. Some of the work can be tedious and repetitive, and even the best artists must be prepared for occasional periods of unemployment, so constant interest and deep love of the work and all its possibilities are necessary.

You Are Here

Do you have the base skills to become a makeup or hair artist?

Are you obsessed with the intricacies of appearance? The best makeup artists are less interested in beauty than in the wide range of aesthetics. In theater, every day is Halloween to the nth degree as you might play with eyebrows, noses, and chins to give a character distinction. A face should match the character, be it creepy, comic, or cute. The simplest stroke of shadow changes someone's appearance, and good artists think and work hard to find the perfect palette. Even a job that seems simple, like devising modern makeup for a small cast, has its challenges and need its layers. If you are someone who will be disappointed with such an assignment because you would rather be playing with warts and blood, this work is not for you.

Are you endlessly creative and see challenges in simple work? While the makeup and hair designs that usually get singled out for excellence tend to be fantasy or effects-based, good artists understand that makeup and hair treatments enhance all performances. Even in shows that depict the mundane (for example, *Death of a Salesman*), makeup can really define the character and mood. For the 2005 Broadway revival of Stephen Sondheim's *Sweeney Todd*, the entire show departed radically from the standard version, so that the makeup was less Gothic and more naturalistic and yet haunting. Designer Angelina Avallone worked from

a costume and lighting palette of black, red, and white, with a touch of blue, to give each member of the cast of 10 a look that was individual and yet hewed to the style. The actors were clearly all part of the same bare-bones world. With deceptively simple makeup, star Michael Cerveris became a pale, haggard, and yet decidedly sexy Sweeney, while costar Patti LuPone was a garish and yet appealing Mrs. Lovett with enormous eyes and blood-red lips. This kind of thought and creativity keeps Avallone working as one of the busiest makeup designers on Broadway.

Navigating the Terrain

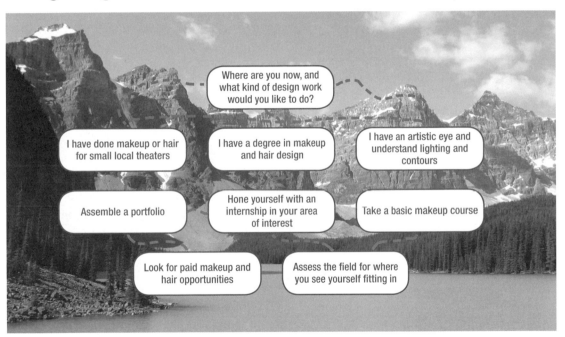

Where are you now, and what kind of design work would you like to do?

I have done makeup or hair for small local theaters

I have a degree in makeup and hair design

I have an artistic eye and understand lighting and contours

Assemble a portfolio

Hone yourself with an internship in your area of interest

Take a basic makeup course

Look for paid makeup and hair opportunities

Assess the field for where you see yourself fitting in

Organizing Your Expedition

Prepare your tool kit as you head into the world of hair and makeup.

Prepare a portfolio. Portfolios seem to be less commonly used for makeup and wig stylists than other crafts. This is perhaps because so many artists in these jobs perfect their crafts from the ground up as interns and assistants and then move forward either through the ranks

or via word of mouth. However, for aspiring fashion makeup artists, a portfolio showing before and after shots of a model, with notes on lighting and sets used, is a must. Theatrical and special effects makeup artists should have portfolios as well. In the case of theatrical artists, it is best to show a range of work with time periods, different stage sizes, and lighting schemes. You want to demonstrate how a facial palette blended with an overall look of a show and its underlying emotional themes. For wig and hair stylists, a portfolio should present shots of a wig at different points in its construction and close-ups of it on the actor's head.

Take some classes. While these crafts can be learned through practice and experience, an aspiring artist can never go wrong taking classes. If you are interested in a degree program and find a good one, so much the better. Most local colleges have a drama department that offers summer classes or something similar. Likewise, vocational schools with an art department offer a range of classes in hair and makeup. Formal coursework not only provides a more solid, all-encompassing grounding in your chosen craft, but it also helps you form contacts and leads to opportunities. Local photographers and theater companies often post internship and job openings on school message boards. Many schools also offer competitions in various craft fields, and placing well in one of these improves your résumé and job outlook. Finally, creating a multitude of styles and palettes in classes quickly builds up your portfolio.

Essential Gear

Makeup and hairstyling supplies. Classes or informational interviews tell you what you will be expected to have on hand on your first day of work. A makeup artist should always carry his or her own tool kit full of brushes, pads, wipes, appropriate makeup for the work, and accessories. A wig and hair stylist needs a hook and needle kit for stitching hair, brushes, combs, curlers, and accessories. It is always best and most professional to amass your own equipment and carry it with you wherever you go.

Hone your experience. Because you learn by doing, you want to constantly experiment with hair and makeup in order to improve your craft. Volunteer for student films, local theater and television, photography studios, and anywhere else that might be able to make use of your services. Look for as wide a range of experience as you can.

Remember that period work varies greatly from Elizabethan England to Revolutionary France to 1920s New York. You want to get to a place where your research, knowledge, and skills mean that you can not only create accuracy in appearance, but use your creativity to devise a look inherent to the show. Remember, too, that you are being hired to be a member of a team, all working together to create the visual aspect of a story. You must be a strong team player, who maintains a sense of compromise, flexibility, and good humor even under the most tense circumstances.

Landmarks

If you are in your twenties . . . If you are not looking to do degree work in hair or makeup, you should look for an opportunity to apprentice yourself to a craftsperson in your chosen specialty. If you are not sure which way you want to go in makeup, now is a good time to try your hand at several kinds of work for short-term assignments to find where your passions and talents lie.

If you are in your thirties or forties . . . If you have some background in hair or makeup in any capacity, you should look for jobs in small venues while building up your portfolio and perhaps taking a few classes to shore up your skills.

If you are in your fifties . . . If you have a range of experience in your chosen capacity, such as work in the fashion or photography fields, you can apply for jobs in small venues where you might be able to work one-on-one with a photographer or designer, quickly building experience and skills while earning.

If you are over sixty . . . If you have not been as involved with the crafts, you should take a few classes to refresh yourself, learn the current materials and techniques, and get material for your portfolio, as well as making contacts. Your teacher may be able to make some suggestions and get you some meetings with someone in your chosen specialty. You should also look for opportunities both paid and unpaid in smaller venues.

Notes from the Field

Melinda Klayman
Hair/wig stylist
San Francisco, California

What were you doing before you got into hair and wig styling?

My degree was in art and art history. I did some work in the art world for a while but wasn't really satisfied, as most of my jobs were more administrative than creative. Eventually I decided to pursue a master's degree focusing on the depiction of hair in art.

Why did you get into hair and wig styling?

I'd always been fascinated with hair and the way it can be beautiful, or, in the case of a creature like Medusa, part of a monster's hideousness. For years I'd treated my own hair as an art project, playing with color, length, and style. When I was living in New York, I got inspired by Wigstock, an annual event showcasing wild wigs. Gradually, I found I had an eye for cutting and styling in general, although this was not something I wanted to do in any traditional sort of way. But I began looking for opportunities to style hair artistically.

How did you get into hair and wig styling?

While I was working on my thesis, I wanted to mix a hands-on approach to hair in art along with a research-based discussion. So I started working with experimental artists to style hair and design wigs, either as live installations, or for performances. After I graduated, an opportunity arose to work for an experimental theater group, and I jumped at it. The work was insane, because they had a lot of great ideas and virtually no budget. I had learned a lot from all my research, coursework, and

Further Resources

***The Professional Make-up Artist, Volume I* by Joe Blasco and Vincent J. R. Kehoe** A detailed book, full of pictures, that can provide a beginner's education in the world of makeup for film, photography, and stage. Available at http://www.joeblasco.com

***Theatrical Costume, Masks, Make-Up and Wigs: A Bibliography and Iconography* by Sidney J. Jowers** A reference book available in schools,

practical experience, but this was a trial by fire. I learned to do things with hair, netting, batting, and a glue gun that I wouldn't have thought possible. As much as the group experimented onstage, I experimented backstage. I couldn't make a living at it, I had to have another job on the side. But it was a lot of fun and really rewarding.

What are the keys to success in this career?

You have to be really inventive. When someone asks for something, and you know there's no way it can be tricked to look the way they want and fit the budget, you have to be able to tell them as much but then suggest several alternatives. Once ideas are agreed on and approved, you have to work fast, because you never have as much time as you think. You can't ever afford to panic. No matter where you're working, things go wrong and it's your job to fix them and you just have to do it—you can't waste time thinking about it. We built wigs that weren't ready for a performer to try on until the day of the performance, and they always needed some adjustment. We just did whatever we had to so that they worked. And even once the wig is done and in the show, you can't relax. One time, an actor in an elaborate drag role missed his mark and snagged his wig coming offstage. No one in the audience noticed, but I had about three minutes to fix the loose hairs and readjust the flower arrangement before he went back on. It should have been impossible, but because it had to be done, it was done. You also have to have a really good attitude. The cast and production team were always amazing, and we were a fun group, but it was still really hard, stressful work. I was very much part of a great team with the costume and set designer. Even when we'd been working 14-hour days all weekend, we still laughed a lot and loved every minute of it.

libraries, or on Amazon, but be aware it costs $410. However, it is an indispensable source for students and professionals alike, including illustrations from the eighteenth to twentieth centuries and indexes listing designers, productions, performers, and authors.

Makeup Artist Forum A forum for people working in the field or aspirants to exchange information and ideas.

http://www.indeed.com/forum/job/makeup-artist.html

Announcer/Voice-Over Artist

Announcer/Voice-Over Artist

Career Compasses

Find the path to using your voice professionally.

Relevant Knowledge of the industry, the wide range of skills needed to do well, and a breadth of information (20%)

Organizational Skills to keep track of not just your work, but everything going on around you, all while remaining on schedule (20%)

Communication Skills as either an announcer or voice-over actor, you must be able to communicate clearly and engagingly to your audience, as well as with your production team (50%)

Ability to Manage Stress when working difficult hours on a tight deadline and schedule (10%)

Destination: Announcer/Voice-Over Artist

You hear them on radio, on television, in film trailers, and in animated films. Sometimes they are famous actors, but most of the time, the announcer or voice-over performer is a well-trained individual who specializes in this field. While employment opportunities are presently on the decline, if you have a good voice and an interest in using it professionally, you may consider pursuing this exciting work.

The tasks of radio and television announcers will vary from station to station, depending on the size and nature of the programming. Overall, an announcer might expect to broadcast station information, such as call numbers, program schedules, commercial breaks, and public service announcements. They introduce and close programs. Some announcers present news, sports, the weather, and local commercials. They often read from prepared scripts, although there is space for ad-libbing in many markets. Many announcers do their own research and writing of the scripts. For a talk show, they interview guests and moderate discussion groups. Announcers give commentary and play-by-play information during sporting events, political debates, election coverage, and other such events. As an announcer becomes known, whether in a large or small market, he or she is expecting to make promotional appearances and do remote broadcasts.

In a smaller market, announcers usually have more technical tasks in addition to those above, such as working the control board, monitoring the transmitter, selling commercial time, logging the daily programming, and creating commercials. Because so much of what was once on tape is now on a digital file, announcers who perform these tasks must be up to date with technology as well.

Voice acting can be done in a number of arenas. An actor might play the part of a computer, for example, such as HAL in the movie *2001*. They also play radio dispatchers, nagging mothers on answering machines, and futuristic cars and elevators. A voice actor can also do "stunt double" voices. If an actor's voice becomes strained, someone else steps in and imitates his or her voice so that the recording can be completed. For the 2004 extended cut Collector's Edition DVD of *The Good, the Bad and the Ugly*, the sound in some of the reinserted scenes was unusable so dialogue had to be

Essential Gear

Organization systems. The law of averages will work better for you in this field if you keep up with the information needs of the career. Whether you are more electronically oriented (and have the relevant machines) or veer on the side of old-fashioned legal pads, you have to track queries, dates for follow-up, professional organizations and the people in them, as well as social connections that may lead in fruitful directions. By doing a good job of managing logicstics, you become free to focus on delivering your best work when it counts.

re-recorded. While Clint Eastwood and Eli Wallach were available, Lee Van Cleef was long-dead, so a substitute was brought in to recreate his menacing tone. *The Good, the Bad and the Ugly* is another example of common voice work—dubbing. Around the world, many actors get regular work by overdubbing the soundtrack into the regional language.

The bulk of the work is in radio and television commercials. Whether in local or national markets, a range of voices are needed, and people of all ages can get good and even sometimes steady work this way. While the quality and flexibility of the voice is what matters, as well as an understanding of how to sell using just your voice, most people who voice advertisements have also had some acting training.

Voice work used to be done by performers whose names were never known to the general public. One of the most famous exceptions was Mel Blanc, the "Man of a Thousand Voices," who gave voice to all the Warner Brothers' cartoon characters, including Bugs Bunny and Daffy Duck. Increasingly, actors who are already famous in film are being tapped to do the voice work in animated films. This growing trend is eliminating jobs for voice specialists. Voice actors, particularly women, still find a lot of work in television because they are often cast to voice young boys. The most famous current example is Nancy Cartwright, who has voiced 10-year-old Bart Simpson for nearly 20 years. The agelessness of animation has given acclaimed voice actress June Foray a long career as well—the senior citizen, most famous for being the voice of Rocky the squirrel in *The Adventures of Rocky and Bullwinkle*, still does voice work.

Voice actors mostly learn their trade in acting schools, but continuing education programs and short courses are available. To work regularly in the field, one must usually be in a major market like New York, Chicago, or Los Angeles, although the continuing improvements in digital technology may allow actors more flexibility.

Announcers usually undergo a long period of on-the-job training, wherein they spend several years gaining experience in the industry before they are invited to do any on-air work. Announcers often get degrees in broadcasting from a college or technical school, where they learn a number of skills including the increasingly important technological management. They tend to have a degree in either communications, broadcasting, or journalism. Courses in public speaking, theater, and foreign languages enhance résumés and abilities, as does a knowledge

of sports and music. Many announcers volunteer for their high school and college radio stations, gaining valuable experience. Internships, whether paid or unpaid, are also an excellent entry point to the industry, providing hands-on training and the opportunity to make all-important contacts. While unpaid internships are far more common and usually given to students needing college credits, they should be sought by anyone interested because doing well in such a position can lead to a paid internship. Interns are often given the opportunity to do more involved work, which can sometimes include actual broadcasting.

The first actual job an aspiring announcer gets in most markets is that of production assistant, researcher, or reporter. When they have demonstrated their capacity for on-air work, they are slowly transitioned in. Typical first-time on-air jobs may be substituting in a smaller market or doing the late-night shift in a larger one. Mostly, announcers start out by taping interviews to control mistakes and gain familiarity with the equipment and protocol.

Essential Gear

Demo tape. The most important element of your announcer/voice-over artist toolkit is your demo tape. Not only will you have taken the steps to make a quality recording that gives a true impression of your voice, you will also have carefully selected a range of genres to display your talents. Not everyone has an edgy voice; only some people can be the voice for a fabric softener. Do what is right for you, and do it well.

Announcers must, of course, have perfect diction, grammar, and breath control. Their voices have to be pleasant, engaging, and controlled. They should have a pronounced personality and style to attract and keep listeners. They should have a wide range of knowledge so that they might broadcast intelligently about any given subject. An announcer or voice performer in any capacity must be able to tailor his or her voice to the emotional heft of the subject. If recording a trailer for a horror film, the performer must sound ominous; whereas a sex comedy requires a light, winking tone.

The competition in this shifting field is keen, but a strong voice and passion for the work, as well as the patience to study the craft and work your way up, will propel you along. Be prepared for whatever opportunity may come up, and expect to enjoy yourself at every level.

You Are Here

Determine if you have what it takes to make money by talking.

Do you have a strong, unique, engaging voice? For either voice acting or announcing, the quality of your voice is what counts. If people enjoy listening to you and want to hear you speak, that is a good sign that you may have the sort of voice that could work on radio. A successful voice actor must also be able to manipulate his or her voice in myriad ways. The more voices and accents you can do, the more work you will get. Actors are regularly hired to record books on tape and CD. The actor who can successfully create a whole world of characters for such an assignment is one who will be asked to do it again and again. While the pay for such jobs is usually not very high, it can be steady work.

Do you have good computer and information technology skills? Whether in large markets or small, announcers may have to use digital broadcasting devices and editing equipment. Computers increasingly are at the center of every aspect of broadcasting, and an announcer is expected to at least know how all the equipment works, if not actually control the equipment. Furthermore, digital transmission allows for more remote operation of stations, meaning that several stations are operated from one central office. Some use satellite feeds for their overnight programming so that they can operate without staff. However, someone is usually on board overseeing all this to make sure nothing goes wrong or to fix things if they do break down.

Do you mind keeping odd hours? Your first jobs in broadcasting will be hosting late-night programs, which will mean getting to work at midnight or earlier and probably staying until 6 A.M. This can make for an awkward sleep schedule and social life and not everyone has the capacity for it. Even if you become a popular morning host, that may mean getting up at 2 A.M. to be at the station and prepared in time to broadcast for several hours. You will be expected to be alert and do quality work. As you prove yourself on the job, you should gain better assignments.

Navigating the Terrain

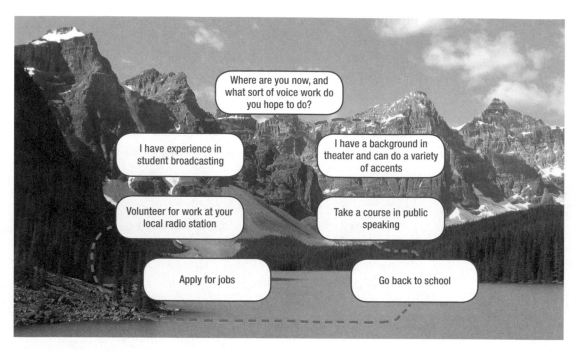

Where are you now, and what sort of voice work do you hope to do?

I have experience in student broadcasting

I have a background in theater and can do a variety of accents

Volunteer for work at your local radio station

Take a course in public speaking

Apply for jobs

Go back to school

Organizing Your Expedition

Prepare yourself for a journey into the world of vocal work.

Improve your writing skills. Announcers in radio, whatever the market, usually write their own material. Even those who seem to be working off the cuff have written at least an outline of their program. For announcers whose programs deal in current events, this script must be written under very tight deadlines, often only hours before the broadcast. A poor script means a weak broadcast, so announcers must always be on their game. Additionally, you must have strong ad-libbing skills, because some ad-libbing is almost always called for in every broadcast, particularly when conducting an interview. You will not be expected to be as clever as Jon Stewart or Stephen Colbert, but you should be able to alter a script or go with a change on the spot.

Ask for informational interviews. Particularly if you are only now considering a career in broadcasting and wish to do a degree program in it, you should get some good information prior to applying. Contact the personnel managers of your local radio stations, especially if there is one whose output you really like, and ask him or her if you can meet for a short informational interview. Most are happy to talk about their work and give you advice if they see that you are serious about the profession. Ask their opinion of the school or program you are considering. They can explain the sort of basic training you need to get a good internship or entry-level job. Beyond getting good advice for educational opportunities, an informational interview can create a strong contact and possibly a hands-on opportunity. Your local station always needs more smart, enthusiastic people on board who are willing to work for free in exchange for learning the ropes.

Volunteer to do voice work in student or community projects. A piece of animation done as an educational film, political campaign ad, public service announcement, or short entertainment all need voice-overs. Make yourself available for this work by placing ads in free papers, on bulletin boards at applicable schools, and other community outlets. Increasingly, clever animated bits make their way onto the Internet via YouTube and iFilm. While they may not retain their popularity for long, online films can help you gain a little attention and bolster your résumé.

Sharpen your fields of expertise. Public and talk radio hosts engage in a number of different topics. Most radio stations, especially in smaller markets, are eager for new and attention-getting programming. Certain subjects are always useful to know about, such as politics, finance, sports, and health. If you can create a program idea with a unique spin on a popular topic, the station manager might be willing to try it out. Tailor a program idea to your area. Local concerns about education, the environment, or lighter fare such as culture and food, can all be fodder for a strong, interesting program. A host who shows inventiveness, wit, and flair will get noticed, and might get offered a position with a national radio program.

Notes from the Field

Joshua Snyder
Voice-over actor
Los Angeles, California

What were you doing before you decided to change careers?

I'd gotten my degree in English and film and wasn't sure exactly what I wanted to do. I knew that I wanted to pursue acting in some way but I couldn't determine my course. Then I saw an ad for a voice-over class and I thought that looked interesting and I decided to sign up.

Why did you change your career?

I liked the freedom of it. It's part-time, so you can make your own schedule. And it's never the same thing. It's really varied. I also like that it's acting, but you don't have to think about your image. That's a nice break. It pays well for doing something that gives you a nice rush.

How did you make the transition?

It was a long and expensive process. You have to take classes to learn the technique, and they're not cheap. You also need to make a vocal

Landmarks

If you are in your twenties . . . If you are interested in broadcasting, you should definitely apply for a formal training program. If you need to work as well, certain programs let you study part-time. This is a good time to seek out unpaid internships that offer college credits, as well as volunteer for broadcasting opportunities with the school's radio station.

If you are in your thirties or forties . . . If you have not any of the usual educational qualifications for either announcing or voice acting, you might consider at least a part-time program at a school of continuing education, just to ground yourself and get some opportunities, as well as make contacts. If you are an expert in a particular field that is discussed on your local radio station, ask to be an assistant with that program.

demo reel, and then I paid to place it online so people could sample it. There was a lot of work to do in finding out about auditions, going to them, and finding an agent. My first paid job I got through my voice-over teacher, because the teacher also did casting. But it took several more months before I landed something on my own.

What are the keys to success in your career?

A lot of practice and a lot of listening. You have to listen to ads. Don't flip through them on the TiVO. Listen to how people speak. And talk to yourself. People will look at you like you're crazy, but that's how you improve your technique. Take as many classes as you can. You can't think you know what you're doing because you don't. There's a lot of work to do in learning how to control your voice so it's effective, and you don't hurt yourself. You have to learn how to sound genuine, which is why acting helps a lot. You're not just reading, you're getting into a character. And you have to be able to follow directions and pay attention when you're in the booth. It's an unusual environment, and you have to be able to adapt to it.

If you are in your fifties . . . If you have been doing acting, you may be ideal to get into voice-over work, especially if you have a distinctive voice and a capacity for a lot of accents. Start by letting all your contacts in the acting world know of your interest in the work. Chances are someone may know a publisher needing a voice actor for a book, which can be a great way to start.

If you are over sixty . . . Look for special events to host as an announcer as a way of getting your voice up to speed and getting attention for your skills. Present ideas for specific programs in areas of your expertise to your local radio station, and indicate that you would be happy to work the late-night shift.

Further Resources

The Associated Press Television and Radio Association Active in California, Nevada, Hawaii, Arizona, New Mexico, Washington and Idaho, APTRA seeks to advance journalism via radio and television. It hosts the APTRA Academy, specifically for aspiring radio and television announcers. http://www.aptra.com

NPR internship program National Public Radio has internships available for either winter/spring, summer, or fall, based either in Washington, DC, or Culver City, California. Candidates must be undergrads, grad students, or have graduated within the last year. NPR also has a show called "Intern Edition," run entirely by the interns, so you get even more experience. http://www.npr.org

Voice-Over Experts Series of podcasts for aspiring voice-over artists, including job opportunities, tips and tricks, and contributions from successful voice workers. http://podcasts.voices.com

Sports Promoter

Sports Promoter

Career Compasses

Break for daylight with a career in sports promotion.

Relevant Knowledge of sports in general, the sport in which you are working in particular, and all aspects of marketing and promotion (25%)

Caring about the sport for which you are doing the promotion and the specific person, team, or club you're working for (20%)

Communication Skills to work with the media, athletes, arena owners, and potential sponsors (30%)

Organizational Skills to keep track of your various events and all their details (25%)

Destination: Sports Promoter

Just because millions of sports fans are out there does not mean they all go to games or otherwise spend money to support teams and events. So, whether on a small scale or as part of a large corporation, good sports promoters are needed to get people get excited about sporting events so that they get out there and start cheering.

Sports promoters often specialize in a particular sport or area of sports. Those obsessed with baseball typically promote baseball, and

those who love soccer beat the drum for that game. Promoters also specialize in winter sports, track and field, children's events, women's events, the Olympics, and any other number of sporting events. Indoor sports like gymnastics, bowling, table tennis, and billiards also need good promoters to keep the interest alive.

Sports promotion is essentially highly targeted marketing and public relations. A background in marketing and advertising, combined with a passion for and knowledge of sports, is necessary to enter and do well in this competitive field. A global enthusiasm for spectator sports has led to a massive increase in all aspects of its marketing. It is no longer just the Super Bowl, Indianapolis 500, and the World Series. Formula One racing, soccer's World Cup, and major tennis tournaments draw international attention with multimillion dollar media rights, merchandising opportunities, and the potential for enormous sponsorship deals. The competition for audience and sponsorship is stiff, so it is no wonder that every aspect of the sports world is eager to hire more good promoters at local and national levels.

A good sports promoter must be innovative. Long before snowboarding became an Olympic sport, fans and promoters created and self-sponsored showcase events and invited the media to come with the promise of exhilarating athletics and a good time. It is harder to get people excited about sports that are not as inherently glamorous, or have no history of play in the U.S. Events like the 1999 Women's World Cup went a long way towards generating more interest in women's soccer, both from aspiring players and those who came out to support them. However, promoters soon found that when stars Brandi Chastain and Mia Hamm were not on the pitch, audiences did not linger. Although the most popular sport everywhere else in the world, soccer is not as understood in America. Promoters have struggled to find an interesting way to both teach the game to would-be fans, as well as bring more of them to events. Even the popular 2002 film *Bend It Like Beckham*—a soccer story about young women that brought audiences to the cinema in droves, failed to really ignite interest in the sport. Men's soccer has fared even worse, and the much ballyhooed hiring of international superstar David Beckham has yet to bring more fans out. Thus, promoters are focusing their energies on the kids who play soccer. These numbers are growing daily, and promoters hope their hard work will pay off in a few years. Believers think soccer will take its place beside baseball, basketball, and football in American interest and sponsorship dollars.

A sports promoter can work for a small league or club, a major team, or an umbrella organization. The inherent nature of the work is the same no matter the size—the promotion of the players as well as the games themselves so audiences will attend. Anyone looking to hire a sports promoter wants to see a background in marketing and communications, an understanding of trends and consumer behavior, and issues like branding, advertising strategy, and sponsorship. They want to see innovation and initiative. How good are you at publicity and liaising with athletes, arenas, and the public? Do you have ideas for fundraising and mitigating losses? Do you have clever ideas for cross-promotion and sponsorship?

Essential Gear

PowerPoint presentation. If you are asked for an interview, be prepared to do a short visual presentation of a possible event idea. You do not have to be as elaborate as Al Gore, but people respond to visuals and a professional presentation will show your passion, originality, and savvy.

While you may be a brilliant marketer and know all the intricacies of a particular sport, it is usually best to work for either an arena manager or sports promoter before setting up your own business if you want to work independently. Just because you have attended sporting events since you were a child does not mean you know how they are set up and run. And you may have excellent ideas for the next great tournament or yearly event, but you must understand all the practical aspects of this particular industry before presenting it if you hope to be taken seriously.

The current need for sports promotion to kids is a worrying trend. Traditionally, boys have been a guaranteed audience at sporting events. But the dueling distractions of school and technology, as well as skyrocketing ticket prices, have meant decreasing audiences in all age groups for live sporting events. Many modern American boys would rather play on their Wii or Xbox than go see a baseball game or play a pickup game in the park. So most venues, large or small, are looking for sports promoters with innovative ideas to get kids excited about going out to see live sporting events.

Another challenge for sports promoters is in getting young girls and grown women to become more active sports fans. While girls have always been a natural audience for figure skating and tennis, getting them actively interested in what is usually considered a masculine province

is harder work. Recently, such superstars as Michelle Wie in golf and Danica Patrick in auto racing have broken down barriers in terms of participation. They are showing young girls that these sports can include them and be exciting to support as well.

Although the competition for sports promotion jobs is stiff, it is a rapidly growing field, especially for the less-popular sports that need enthusiastic and talented promoters. If you have a knack for marketing and a love for sports, this may be your dream job come true.

You Are Here

Work your way into the world of sports promotion.

Do you have a background in marketing, communications, or advertising? One or all of these abilities is going to help you tremendously as you venture into sports promotion. Of course, some promoters have become successful simply on innate good sense and charisma, but having a strong set of business and communications skills behind you can help you break into this field. Since the bulk of sports promoters begin their careers working for a club, arena, or another sports promoter, your résumé is going to have to stand out. Make sure it features all skills and experience you have related to promotion.

Do you have intimate knowledge of a range of sports? The legendary baseball teams get reams of applications from aspiring promoters who have been fans since they could toddle. That is great, of course, and being a baseball fan should not stop you from looking for jobs in baseball promotion. However, if you are also adept with less-popular sports, this opens up your job prospects. For anyone interested in trying to start up their own business, you should widen your field of interest.

Are you media and fundraising-savvy? If you get a job for the Yankees, you probably do not need to be concerned about getting media attention or raising money for events, but if you are hired to promote champion badminton, you have a bit more work to do. If you can come up with bold ideas and know how to entice various members of the media, including

print, broadcast, and Internet, you can quickly make a name for yourself. Couple that with an ability to raise funds and get people excited about being involved, and you will definitely be on your way to a successful career in this field.

Navigating the Terrain

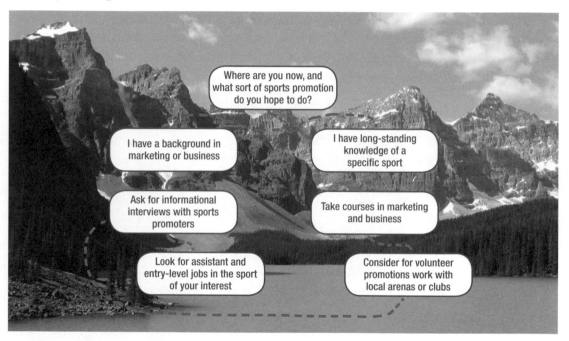

Where are you now, and what sort of sports promotion do you hope to do?

I have a background in marketing or business

I have long-standing knowledge of a specific sport

Ask for informational interviews with sports promoters

Take courses in marketing and business

Look for assistant and entry-level jobs in the sport of your interest

Consider for volunteer promotions work with local arenas or clubs

Organizing Your Expedition

Have everything set for your trek into sports promotion.

Ask for as many informational interviews as you can. Even if you have a degree in marketing and communications, translating that to a specific job as a sports promoter requires a certain skill set. While it is great to get into a field about which you are passionate, sometimes that passion can actually work against you. You can be so involved, you may not be as practical and forward-thinking as the job entails. Meeting with people who have successfully parlayed that same passion into a satisfactory

career gives you the opportunity to learn how to let your passions work for you and how to channel them into greater efficiency. Most people love to answer questions about their work and their career trajectory. They are happy to sit down with you for at least 15 or 20 minutes and tell you stories and give advice. These sorts of meetings can be invaluable. You not only get a free lesson in the ins and outs of your chosen field, you make contacts who might be able to help you further down the line. Some informational interviews even lead to paying jobs.

Essential Gear

List of suggestions. In addition to highlighting a specific idea with a more detailed presentation, you should even enter informational interviews with a list of possible marketing ideas. An experienced sports promoter can look at them and give you some advice and help you tailor them to your job interview.

Improve your understanding of branding. Creating and copyrighting an event is a great way to promote a sport and build a name for yourself. A branded media event can entice kids without being obvious that the idea is to pull them out of their sedentary lifestyle. Sports organizations are hungry for events that mix entertainment, intimate star participation, a bit of history, and an opportunity for kids to learn and play with the stars. Study successful events and draw up several ideas for capitalizing on them while creating unique programs that can spark a wider, more sustained interest in a specific sport. Look for cross-promotional opportunities. An organization will be especially interested if you can find a way to tie in a popular video game or comic book. Add some merchandising possibilities beyond the usual T-shirts and hats and you will definitely be on a successful track.

Be Internet savvy. There is no way to be in marketing these days and not be up on Internet techniques, but for the bulk of modern sports promotion, you need to be a wizard—especially with the all-important need to market to kids. You must be up to date with all the hottest Web sites and anything that can tie into your sport. You must also develop interesting Internet advertising and cross-promotion. Kids will always be a step ahead of you, but if you are following closely, you can keep up and maybe start to draw them away from their computers and out onto the playing field.

Stories from the Field

Don King
Boxing promoter
New York, New York

Despite being controversial and having some questionable ties and an often-mocked hairstyle, there is no denying that Don King is a master of sports promotion. Combining intelligence and charisma and a strong marketing sense, he is rightfully earned his place in the Boxing Hall of Fame.

King grew up in a Cleveland ghetto. He was a small-time bookmaker and later convicted of manslaughter. While in prison, he decided to educate himself and read voraciously. Upon his release, he entered the world of boxing. Although boxing was starting to have some black athletes, the sport had no black promoters of note. King soon made a name for himself by convincing Muhammad Ali to box in a charity exhibition for a Cleveland hospital. Although he had contacts willing to invest in events, he did not know a great deal about the fight world. He formed a partnership with Don Elbaum, a boxing manager, whose knowledge was all he needed to skyrocket to success.

In 1974, King staged one of the most memorable championship fights in boxing history, pairing Ali and George Foreman in the Democratic Republic of Congo, then known as Zaire. This fight was labeled "The

Gain expertise in an arcane field. One way to get a leg up as you begin your career in sports promotion is to focus on a sport that has a harder time getting attention. When the old Scottish winter sport of curling was reintroduced to the Olympics in 1998, promoters eager to get an audience and coverage had no end of work to do. The game looks bizarre and is hard to explain. Promoters used the amusement factor of the sport—that brooms are involved—to their advantage. They employed such tactics as getting prominent sports reporters to try and play the game. This worked well because the reporters were exhilarated and exhausted, and curling started to gain respect. Membership in the U.S. Curling Association is now growing. There may also be the inevitable risqué calendar of curling athletes in the works. But curling still needs a lot of innovative promotion, and this can be a more challenging and ultimately satisfying route to take than promoting more traditional baseball or basketball.

Rumble in the Jungle," and King landed a $10 million purse for it, which was a new record. The next year, he promoted an event that sealed his reputation as the sport's preeminent promoter. This was the third rematch between Ali and Joe Frazier in Manila, the Philippines. King dubbed this fight the "Thrilla in Manila," and it too drew enormous interest and investment.

King has gone on to set a number of boxing records, some more than once. He twice promoted six world title fights on one card, and has promoted more than 20 world title fights in a year—not just once, but three times. More than 90 fighters have fought under the Don King Production, Inc. banner, including Ali, Roberto Duran, Larry Holmes, Julio Cesar Chavez, and Mike Tyson.

King has been featured on the covers of *Time* and *Sports Illustrated* and was inducted into the Boxing Hall of Fame in 1997. Boxing's three major sanctioning bodies have called him the "Greatest Promoter in History." He is been the subject of television movies and media spoofs and was listed by the *New York Times* as one of the 100 African Americans who have helped shape the nation's history over the past century. While he has continued to court some controversy, he is also worked hard and stands at the top of his profession. As King himself has said so frequently, "only in America."

Landmarks

If you are in your twenties . . . If you have a degree in marketing and/or communications and a lot of Internet savvy, you are a desirable candidate in almost any sports promotion office. Employers assume that you know a lot about popular comics, video games, and Web sites and have original and exciting ideas for marketing sports to a younger audience.

If you are in your thirties or forties . . . If you have kids as well as the requisite background and knowledge, you are desirable for the same reason as someone in their twenties. Employers expect you to be keyed into the Internet and other entertainment outlets popular with kids. You have a strong sense of how to create appealing promotional events to draw young audiences in, along with their parents.

If you are in your fifties . . . With a strong marketing and business background and some sports-related experience and/or knowledge, you should start looking for small ways to be involved with start-up events as a means of building up your résumé while you look for full-time sports promotion work.

If you are over sixty . . . With the requisite background and extensive knowledge of an arcane or underappreciated sport, create some original ideas for events to promote that sport and approach clubs and arenas. Chances are, the sport is hungry for some fresh minds, and someone with a lot of related experience and real interest is going to be welcomed.

Further Resources

The Ultimate Guide to Sport Event Management and Marketing **by Stedman Graham, Joe Jeff Goldblatt, and Lisa Delpy** Available online via Amazon and at major bookstores.
The Dream Job: Sports Publicity, Promotion and Marketing, 3rd edition **by Melvin Helitzer** Available online via Amazon and at major bookstores.

✚ Critic

Career Compasses

Chart your course to the critic's life.

Relevant Knowledge of the medium you are reviewing and its variants and history (40%)

Caring about the medium as a whole, because part of your job is to make it better through considered discussion (30%)

Communication Skills to guide readers or listeners to see or avoid whatever you have reviewed (20%)

Ability to Manage Stress when working on a tight deadline or when you have had to see 10 lousy films in a row and it is making you despair (10%)

Destination: Critic

A new film, play, opera, dance, book, restaurant, clothing line—they all get reviewed in the local paper, on television, on radio, or online. Lots of people wildly disagree with the reviews, or ignore them, but just as many people use the reviews to determine whether or not they will spend money on the entertainment, food, or clothing. The reviews are all generated by critics, the best of whom are genuine experts in the particular field about which they are writing.

Everyone's read the reviews that lead them to believe that any idiot can become a critic. There are indeed poor critics with negligible taste, but good critiquing requires both art and skill. In addition to an obsession with a particular field (film, television, fashion, consumer electronics, etc.), most critics have a background in journalism or English. Opinions vary on what makes someone a great critic, but everyone agrees that you have to love the subject matter with a passion. The best critics approach a new entry to the field hoping to be dazzled, but with realistic expectations.

A critic must be open-minded. Good film critics, for example, go to see any film they are assigned and judge it on its merits, even if it is not one of their favorite genres. In fact, good film critics should not be prejudiced against any particular genre because that prejudice will unfairly color the work. You may love romantic comedies and hate war films, but if you are sent to review a war film, your job is to pay attention to its story, characters, script, and direction. A good critic wants to develop a bond with readers. People want to trust reviewers and feel that they always bring thought and care and consideration to whatever they are reviewing. This is not to say that readers will always agree with the review. Many people regularly disagreed with celebrated film critic Pauline Kael of the *New Yorker* magazine. However, she wrote brilliantly, with passion, insight, and intellect, leaving no doubt of her knowledge of cinema and literature and the intensity of consideration she brought to every film reviewed, even when it patently did not deserve it.

The critic's first audience is the general reader.

Just as the film critic loves film, a theater critic must love theater, whether it is Shakespeare or Stoppard, musical or play, comedy or tragedy, experimental or old-fashioned. Many of the best critics in theater have been reviled by producers. Critics can be exacting because they want to see good shows. Modern theater has had a bit of a tough time, because escalating prices have meant smaller audiences and so producers often aim lower, hoping this will help them recoup investments. For critics, this can mean sitting through shows that feel generic and clichéd. Famed columnist Frank Rich was drama critic for the *New York Times* from 1980 to 1993. He was nicknamed "The Butcher of Broadway" for his supposed ability to close a show on the power of a negative review. Producers hated him, but Rich was a theater lover who championed good shows when they came around and rightly castigated

producers who were plainly not interested in art or risk. Previous critics fared even worse. Producer David Merrick tried to get critic Brooks Atkinson fired and producer Joseph Papp physically threw critic Walter Kerr out of the Public Theater. The Wild West atmosphere may not be as strong today, but the animosity between producers and critics certainly continues. A good critic has to have firm convictions and is not afraid to stick to his or her guns when convinced they are in the right.

Critics of books or food or clothing are not as much in the public eye, but this does not make their job any easier. They still must read or sample thoroughly and report their opinion with an exacting, but fair, eye. While the work can be fun for the person who is reviewing a subject he or she loves, it can also be frustrating—slogging through an unreadable book, watching an interminable film, or gagging on inedible food. A good sense of humor helps. Contrary to popular belief, critics really do not enjoy having to slam a subject, but it has been observed that the slams are usually the funniest reviews. For a good critic, applying a little humor to what was a miserable time is the best antidote to the pain.

Essential Gear

Clip file. The beauty of having your own Web site is that you can quickly create a clip file of reviews to show potential employers. Your file should show your breadth of interest and ability, as well as your unique style and expertise. Have a printed file with you whenever you meet someone about possible work, or even just networking. They may want to read a short piece then and there, and you do not want to have to ask them to jump on the Internet to do so.

Critics also have to have a good sense of humor about their work in general. Critics are often criticized in turn or even mercilessly spoofed in popular culture. When film critic Roger Ebert reviewed films on television with critic Gene Siskel, they were the constant subjects of satire. Food critics are perceived as being some of the most pretentious reviewers of all, although this was rather lovingly depicted through the character Anton Ego in the animated hit *Ratatouille*. The film even made rather a good point about the job and nature of criticism in this little speech: "In many ways, the work of a critic is easy. We risk very little yet enjoy a position over those who offer up their work and their selves to our judgment. We thrive on negative criticism, which is fun to write and to read. But the bitter truth we critics must face is that, in the grand scheme of

things, the average piece of junk is more meaningful than our criticism designating it so. But there are times when a critic truly risks something, and that is in the discovery and defense of the new."

With many newspaper critics losing their jobs because of a decline in readership, aspiring critics are increasingly looking to the Internet for work. Most critics begin their work writing in college publications and local papers, honing their skills and tastes. Local publications are often in need of a discerning critic who writes well and, while they often provide little compensation, they can at least cover the costs of the review subject, whether it is a meal or a play. A critic who shines in such circumstances can gather clips and gradually move upwards. Aspiring critics these days can also create their own Web site dedicated to their reviews and use links and key words to gain readership and, hopefully, popularity.

Critics should be open to writing for a few different publications.

Inventive critics who demonstrate clear passion for their subject can still make a name and gain some influence, and as frustrating as the job can be when the work is terrible, the rewards of this career are priceless when something is wonderful.

You Are Here

See if you have what it takes to write objective opinions.

Do you have a passion for a subject in all its forms and history? Most critic jobs only cover the cost of your attendance at the event, although there are often perks. However, critic work can be low-paying, you need a love for film, food, music, theater, or whatever you are reviewing to propel you forward. Your taste must be wide-ranging, and you should have a voracious appetite in all senses of the word. If you want to review films, you should watch older films and read all the best books on film history and criticism. For theater, you should read old plays, study photographs and essays, and learn from old reviews. An English major turned editor might make a perfect book critic, as this is someone who reads for a living anyway. It just cannot be emphasized enough: Your passion must come through.

Do you write well and can you discuss your opinion comprehensibly and engagingly? You cannot simply say "this is good" or "this is awful" about a subject. Your review has to be informative and allow readers to draw their own conclusions about a subject. If you go to an art show and dislike the art, you cannot even just say it is unimaginative. You have to use your knowledge of art and whatever form the artist works in to describe its weaknesses. Likewise, if you love a film, you cannot just say it is amazing. You have to be able to fairly discuss what works in it and why.

Can you write concisely and clearly? The reason so many good critics have a background in English and journalism is that review writing is a combination of essay and article. Even if you give your review on the radio, you still have to write it. And either way, you only have a limited amount of words in which to give your considered opinion. The ability to clearly present your argument for or against something is a skill you perfect as you continue to practice it, but having a strong understanding of good journalism and essay-writing skills from the outset will put you well ahead of the pack.

Navigating the Terrain

Organizing Your Expedition

You need a bit more than a pen and pad to be ready to review.

Start a Web site and/or blog. As more and more respectable on-line outlets like Salon.com become major sources for review-readers, you should develop your own online presence. People interested in reviews often turn to Web sites and well-written blogs, especially if they have a highly specific voice or style or angle. If you are looking to have a long, decently paying career, you cannot rely on your own site to propel you to either fame or fortune. However, as you are starting out, it can be a way to generate interest. You can also refer people to your Web site when looking for work. If you love your subject enough to write about it free on your own site, you are clearly someone to take seriously. If you do have a job writing reviews for a small local paper, you can ask them if you can copy the reviews for your own site as well or set up a link. Most of the time, they will be happy to oblige as it is free publicity for the paper as well. This makes you look even more legitimate.

Essential Gear

Reference library. Even if your interest is in reviewing food, you should still study the collected essays of Pauline Kael or Frank Rich. The techniques they honed for fine, memorable reviewing can be applied anywhere and you should be as well-read in the art of good reviewing as possible.

Look for chances to promote yourself. Major critics are often asked to teach, give seminars or lectures, and host events. You can do the same, although you will have to do the asking. Many community colleges, vocational schools, and schools of continuing education need experts in particular areas to give courses or lectures. A food writer can give seminars in cooking classes or even at a cookware shop. An art writer can lecture at a museum. A book reviewer can host a reading group at a library or bookshop. Be inventive in your choice of event and then prepare, prepare, prepare. You want to sell yourself effectively to your audience. If they respond to you as someone who is intelligent and informed, but also accessible, easy-going, and engaging, they will be far more inclined to start reading your reviews.

Notes from the Field

Jerry Weinstein
Theater/film critic (*Manhattan Living, Nerve, Curtain Up*)
New York, New York

What were you doing before you decided to change careers?

I had a BA in political science and English literature and then took a publishing course at Harvard/Radcliffe, thinking I'd go into teaching and publishing. Instead, I earned an MFA in screenwriting. But then I went back towards publishing by first working for a professor at MIT, editing a textbook, which led to a job at MIT Press. However, I felt I'd enjoy being an arbitrator and writing about things, rather than merely polishing other people's work.

Why did you change your career?

It was a combination of being exposed to and interested in artistic expression from a young age and wanting to say more than I could as an editor. I also saw that writing criticism would be a way to sharpen my writing overall and to help form my point of view. I wanted to be a part of the artistic conversation. Also, I was disappointed in the level of much of the criticism I was reading. I thought it was too pointed and superficial and packaged. I found myself often disagreeing with the major critics and decided that the way to have an impact without just bitching about it was to try your hand at it yourself. My theater teacher in my MFA program said that critics are a part of the community, that they are there to help make the work better. I wanted to be a part of that construction.

How did you make the transition?

I looked for opportunities in small media. There is no shortage of places that pay little or nothing, both online and in print. I had some clips from when I was in Cambridge, so when I moved back to New York, I found

Find an angle. Having a specific angle can help you get noticed and carve a niche for yourself. The *New York Times* used to run a feature called "Taking the Children" which consisted of movie reviews written by parents for parents. They broke the films down in terms of language, violence, and sexual content, and the various age groups for which they might be appropriate, noting when a five-year-old would fall asleep or an

a few good places to work for, like *Culture Vulture*. There, they let you get your feet wet and then help you make contacts and move forward. I also wrote for *Curtain Up*, where the editor is very hands-off in a good way. My feeling was that, if I couldn't get paid, I wanted to work with people who could teach me and help me find my voice through practice. Later, when I was working for more national publications, I found that some of the editors were actually not as good as the ones for whom I wrote pieces that only comped me for the tickets.

What are the keys to success in your career?

The only way to really know your subject is to keep current. You have to keep building your knowledge and be able to reference stuff from two years ago as readily as 50 years ago. You also want to figure out where your area of expertise lies and develop a focus. When I was writing for *Curtain Up*, the editor soon saw that I was really good at reviewing quirky things that not everyone on staff wanted to see. I liked shows that were experimental or had a political focus, and I was good at writing about them. So the editor kept me in mind for those sorts of assignments, and I developed a good voice. Developing a voice like that is great for when you approach other publications because they'll see that you have focus and depth. You can always widen your approach, but it can be good to have that initial depth. Another key, at least for me, is that I've always found that the freshest writing is the most authentic and valid writing. When I write a draft of a review the evening after seeing a play, it's 90 percent done. But if I see an early preview and then don't finish the review till opening night, it's not as strong. Finally, it's great to establish a rapport with an editor. If you're working for free and they like you, they might be willing to give you a paid position if they have invested in you. Or they might know another good outlet for you to try. You definitely want to have some strong contacts.

11-year-old would be antsy. The reviews were also clever and engaging and pulled no punches, as when a children's film was dismissed as insulting even to a child. Parents are often starved for reviews that are this specific and intelligent. So if you are a movie-going parent who writes well, you might consider this angle. For whatever subject you wish to review, having a strong, individual voice can help in garnering you work

and readership. Nor do you have to limit yourself. The parents writing for "Taking the Children" reviewed popular R-rated fare as well as the G-rated pictures. It is all about determining a voice.

Landmarks

If you are in your twenties . . . You should look for opportunities to write for free in small publications and Web sites while developing your expertise. You are too young to be taken seriously in most businesses, so this is a good time to study your craft and chosen subject. Then, when you are ready to pursue paid work, you can dazzle a potential employer with your breadth and depth of knowledge.

If you are in your thirties or forties . . . If you have a strong field of expertise, you should hone your reviewing skills either in a class or on your Web site while looking for opportunities on a local paper or magazine.

If you are in your fifties . . . If you do not have any journalism experience, you should take a class or two while building up a clip file. You are at a good age to take your expertise in a field and channel it into reviewing, so it will only take a sharpening of journalistic skills to put you in the way of paying opportunities.

If you are over sixty . . . If you are a known expert in a field, you will be an ideal candidate for reviewing. Have some samples ready and approach publications with the expressed interest of joining their staff. If they hesitate, or do not have space for you, offer to do some reviews for free just for the practice. While it may not open a door at that particular publication, having some solid clips like these will help get you work elsewhere.

Further Resources

Awake in the Dark: The Best of Roger Ebert Like his taste or not, he is one of the most influential film critics in America and reading a compendium of his reviews is a good way to understand the technique of film reviewing and the development of a unique voice. The book also includes

some of Ebert's essays on film and a description of his initial foray into the field. Available online from Amazon and at all bookstores.

Hot Seat: Theater Criticism for The New York Times, 1980-1993 **by Frank Rich** A collection of over 300 theater reviews, annotations, essays on theater people and productions, and various remembrances, this is a history of the theater as well as an education in powerful theatrical reviewing. Available online from Amazon and at all bookstores.

The *New York Times* archive Although print reviews are not as influential as they used to be, the reviews of all media from the New York Times are still cited throughout the nation. Look through the archives for food reviews by Ruth Reichl, book reviews by Michiko Kakutani, art reviews by Holland Cotter, and reviews in any other medium in which you might have an interest to see how those who are considered the best in their field do their job.

Photographer

Photographer

Career Compasses

Make your way behind the lens.

Relevant Knowledge of all aspects of digital and silver halide photography, as well as your chosen specialty (30%)

Caring about doing strong, innovative, honest work and capturing your subject at its absolute best (20%)

Communication Skills to work well with models, subjects, assistants, and others in your industry (25%)

Organizational Skills to keep track of your work at every stage of the process, as well as run an effective business (25%)

Destination: Photographer

The advent of digital cameras means that more people are taking more pictures, and when they process them on their computers, they can alter and improve them in a way the average person's 35-millimeter camera never allowed. However, this does not make someone a professional photographer. The skills and creativity essential to a career in paid photography must be honed over a long period of time, involving training and a lot of practice. The competition for paying photography jobs is

pretty fierce, but the constant challenge of the work makes it energizing and fun.

Even though PhotoShop and other computer software programs can twist and change photographs, the unaltered picture is still worth 1,000 words. Still images can provoke, arrest, and move us in a way that words often cannot. Famous photographs throughout the last century continue to have an impact because they either tell or enhance a story. The photos of the rural poor taken by Dorothea Lange during the Great Depression showed people a world about which they read, but had not imagined was so difficult or at times hopeless. Lange eschewed sentiment for relentless honesty. Her photographs told the world exactly what the Depression had wrought, and they had tremendous influence on the growth of documentary photography.

Essential Gear

Digital and silver-halide cameras. Although the bulk of photography done these days is digital, you should still have experience with traditional cameras. They are most often used for artistic photography, but you might find other applications for the traditional methods as you continue in this career. Understanding the history of photography and cameras may also improve your work.

Photographs do not have to show people to strike the heart. The great landscape photographer Ansel Adams took pictures that continue to be sold as posters and prints because they are so vivid, stirring, and alive. Although black and white, his photographic renderings of the American West have a way of seeming a more true portrait than those in living color.

The road to becoming a professional photographer can be expensive because you need quality professional equipment. Although digital cameras mean you no longer need film, you still need top-notch software for processing. Additionally, many professional photographers use a traditional silver-halide film camera in addition to a digital camera, depending on the effect they want to create. Finally, more than half of all photographers work freelance, so you may have little in the way of job security and may find yourself unemployed for long stretches of time. Good word of mouth can bring you more work and you can gradually find other means of augmenting your income while still working on photography. During downturns in employment, budding photographers often devote time to fine-tuning their art.

Being a good photographer is all about having a good eye, as well as know-how, creativity, and a sharp sense of the visually arresting. You must understand the use of light, both natural and artificial, and how to use various lenses to change the look of the photograph. Other equipment involved includes filters, flash attachments and tripods.

When considering a career in professional photography, it can help to choose a specialty. If you find you have got an eye for faces, you may choose to go into portrait photography. Once you get established, this can be a fairly lucrative job, as you can get hired for special occasions such as weddings, bar and bat mitzvahs, and proms. You can also do headshots for actors, school pictures, and family photographs. These professionals usually have their own studios, although the special-occasion work involves going on location. Running a studio can be a lot of fun, but you also need some business basics to advertise, manage a schedule, maintain your supplies and records, and pay bills. You can set your own hours, but be prepared for them to be long and busy. You may even have to devote time to processing film yourself. Sometimes the most stress comes from the subjects themselves. Children may scream or misbehave, adults can be tense and demanding. You have to be more than just a fine artist to be a successful portrait photographer; you have to be calm, encouraging, diplomatic, patient, and have a great sense of humor.

If you are not someone who wants to deal with the general public, a number of other specialties are less people-intensive, such as commercial, industrial, scientific, news, or fine arts photography. In commercial photography, you take pictures of buildings, models, products, artifacts, and landscapes. These images are usually for use in books, reports, advertising, and catalogs. Industrial photography, which is mostly done on location, involves photographing equipment, machinery, products, workers, and officials. The pictures are often used for analysis, publicity, or records.

If you are transitioning from a career based in engineering, medicine, biology, or chemistry, you might consider scientific photography. Understanding scientific procedures means you can take useful photographs that illustrate and record data and phenomena.

One of the more exciting, if dangerous, jobs you can pursue is that of a news photographer or photojournalist. For those who already have a background in journalism, this can be a natural transition. Some of the most iconic images of the last century are photographs taken by news

photographers. The Pulitzer Prize-winning Vietnam War photograph of Kim Phuc Phan Thi, the little girl struck by napalm, running and screaming in agony, was taken by Huynh Cong "Nick" Ut. It was on the cover of Time magazine and is always included in discussions about the conflict. The photo did much to rouse public opinion against the war, and President Richard Nixon openly suspected that it might have been "fixed," knowing that the photo would damage him politically. It was all too real, however, and Ut, even knowing that the photo would have a powerful impact, took all the injured to the hospital before wire-transmitting the film to the Associated Press. Ut knows firsthand how dangerous his job can be. He was wounded three times in Vietnam, and his older brother, also a photographer, was killed.

Journalistic photographs continue to have an impact, which is why the Bush Administration censored images of the dead and wounded returning from Iraq. As dangerous, frustrating, and even heartbreaking as these assignments can be, they are also challenging and vital to making historic records.

Whichever path you choose to pursue as a photographer, know that you are entering a highly competitive field where the wages can be uncertain, but the artistic rewards can be plentiful.

You Are Here

Focus your way into a photography career.

Are you in a job whose skills might lend themselves to news photography work? In addition to the above-mentioned journalism, a news-based photographer might work in sports, politics, or entertainment. If your current career revolves around such fields and you have photography skills, these can be ideal paths to pursue. Likewise, scientific and medical fields regularly need photographers who have an understanding of their respective procedures. Even if you do not see an obvious connection between the job you are in now and a career as a photographer, there may still be one and it is worth taking the time to think outside the box to find it.

Have you taken coursework in photography? You do not have to have a degree in photography, although it can certainly help, especially

for entry-level jobs. However, even the most natural artist can benefit from a few classes in photography, which are offered at universities, junior and community colleges, vocational training schools, technical schools, and even at some high schools through special adult education courses. Even if you already know the basics involving equipment, processing, and techniques, you will certainly benefit from learning more about the business of photography and tricks in design and composition. You might also make some connections and get some leads on employment opportunities.

Do you have excellent business and people skills? Since so many photographers work in a freelance capacity, basic business skills will help. You will need to manage invoices, file taxes, handle a budget, and keep up with other administrative duties. You will also need strong personal skills because work opportunities depend on networking connections and good word of mouth.

Navigating the Terrain

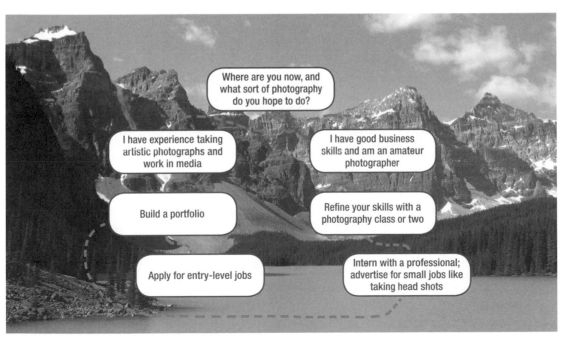

Organizing Your Expedition

Prepare your camera bag before you set out.

Build your portfolio. To land that first job, and second, and third, you need to have a book of photographs for a potential client to browse. As mentioned, most photographers work freelance, so you are constantly having to sell yourself. Whether you are looking for work as a photographer's assistant or trying to get your own gig, no one is going to hire you without being able to see samples of your work. It can be useful to have some initial focus. If you want to get into fashion photography, you do not want to have landscape or industrial pictures cluttering your portfolio. On the other hand, if you are looking to apprentice or work as a photographer's assistant, or want to do some general artistic work, you should have a variety of subjects and styles to show off. Basically, your portfolio should demonstrate your skill, creativity, inventiveness, artistic eye, and abilities to work with various equipment and lighting designs. You might do well to seek out informational interviews with professional photographers and ask their opinion on what constitutes a strong portfolio.

Develop contacts. Successful freelancing is all about contacts. One good way to learn a lot of names and make some initial contacts is by subscribing to newsletters and magazines, both print and online. You should also investigate local camera clubs and volunteer as a photographer for community newspapers or events. Another good way to make contacts while building skills is by asking for a short internship, or otherwise working for free, assisting an established photographer or volunteering at an organization that uses photography. When employers see you're that serious about learning the business, they are that much more inclined to help you along.

Scout your personal terrain. Some art directors at magazines or advertising agencies accept unsolicited queries. If you think you want to work for an ad agency, you should investigate who is open to such queries and contact them accordingly. Most agencies are located in major cities, such as New York, Chicago, and Los Angeles, but there are also smaller

agencies or branches of major ones in other markets and these can likewise be worth pursuing. Likewise, seek out magazines that accept unsolicited photos. Your favorite magazine could be one of them. If this is the case, target your query letter specifically. Let them know that you are a regular reader. Note a few examples of pieces you have liked and tell them exactly why you think your photos would suit their publication. Even if they do not accept them, they may offer some alternate suggestions for sending your work out.

Essential Gear

Portfolio. A collection of the best of your work, which shows off the range of your talent, will be the ticket to impressing potential employers and clients. Even some photography training programs and individual classes ask to see a portfolio before considering you as a student. Building a perfect display of your work that shows range and versatility takes time. It may take several hundred shots to get the perfect portfolio.

Focus on skills. Potential employers want to see work that shows an individual style and a good eye. They also want to see at least a basic grasp of the rudimentary skills. In an entry-level job, you learn more as you go, but you should still know how to use software programs like Adobe PhotoShop and how to set up a basic Web site to advertise your work. You must be detail-oriented and work well with both colleagues and clients. In addition to basic business skills, a freelance photographer should develop some knowledge of copyright law to protect their images and understand contracts and negotiation.

Landmarks

If you are in your twenties . . . If you can take some time before settling into a full-time pursuit, you should experiment in as many different capacities as you can. This is the best way to get a sense of where your passions lie and in what area you have the most talent and skill. Because professional photography can mean constant struggle as a freelancer, you want to find the area about which you're the most excited so that you always love your work.

Notes from the Field

Jason Gardner
Freelance photographer
New York, New York

What were you doing before you decided to change careers?

I was a marketing executive for Internet companies. I worked for a small startup for a couple of years and did some consulting. Then I had what they call a "quarter-life" crisis in my twenties. I just realized I was unfulfilled. So I decided to do some traveling. I traveled for two years, doing a lot of work overseas and taking a lot of photos.

Why did you change your career?

I'd always dreamed of being a photographer, and when I was traveling, I was in a lot of developing countries and got a strong sense of how lucky I was to grow up middle class in America, especially in New York, where you can reinvent yourself. So I decided to follow my bliss. People had looked at my photos from abroad and said I had talent. And I didn't want to go back into an office, I wanted to take a harder road.

How did you make the transition?

The short answer is that I hustled. First, I had to learn the craft. I decided not to take classes. Instead, I called a lot of photographers and offered myself as a free assistant or intern. I wanted to get in the door

If you are in your thirties or forties . . . You should submit work to contests and volunteer to work for free in evenings or weekends to build contacts and a portfolio. Look for ways in which your current career might assist you in transitioning to a career as a photographer and take the appropriate classes to augment your skills.

If you are in your fifties . . . Look for positions as a photographer's assistant as you work on your portfolio. Consider offering initial cut-rate deals for your work as a way of building a client base and reputation. Think about how your career experience so far may lend itself to a specific photography niche. Someone who taught high school biology, for example, might find his or her knowledge helpful in getting into nature photography.

and talk photography and see firsthand how it was done. One of the photographers I worked with advised me against going to school and told me to just shoot a lot and make a lot of mistakes and then keep on doing it because that's the best way to learn.

What are the keys to success in your career?

You have to start by learning the craft. Not just the technical aspects, but also how to compose, how to talk with subjects, when to shoot, and when not to shoot. You have to find your passion and keep shooting it so that you can get known for it. When I was starting out, people told me to specialize. That's good advice, and you should take it to heart, but you should also take it with a grain of salt, because a working photographer just starting out should take every job opportunity that comes up. Also, you should really explore being an intern or assistant in any field. You may not like fashion, but if you get an opportunity to intern there, you should take it, because you'll still learn a lot. Finally, it's all about marketing, marketing, marketing. Work your network. I had a lot of contacts from my previous career and I e-mailed all of them to tell them I was now a photographer and invited them to look at my site, thus transitioning them to seeing me in a different way. So you definitely want to use all your resources. Don't worry about starting big. You can just shoot your daily life and use the setup you have and go from there. If you keep telling people you're a photographer, eventually, that's what you'll be.

If you are over sixty . . . You may want to focus on portrait or artistic photography. If you have a calm demeanor and people relax well around you, you could be an ideal portrait photographer. Although fashion photography is far more fast-paced and stressful, if you have a background in fashion, a good eye, and an easy-going temperament, you might look into this field.

Further Resources

All Art Schools Photography Schools and Career Resource Center
Detailed information about photography schools and programs nationwide, with tips, links, and articles. http://www.allartschools.com/faqs/photography-school.php

Professional Photographers of America An educational and communal resource for photographers offering information and assistance with business, competitions, and membership benefits. http://www.ppa.com

International Center of Photography New York-based museum offering a school and various online resources. You can get study full or part time or get involved with the Community Programs Office, which works with local schools and community centers. http://www.icp.org

Fashion Designer

Fashion Designer

Career Compasses

Thread your way to a life as a fashion designer.

Relevant Knowledge of fabrics, styles, some basic sewing skills, trends, anatomy, and fashion history (30%)

Organizational Skills to keep track of designs at all stages and to juggle swatches and changing styles and manage a business (30%)

Communication Skills to liaise with other designers, stylists, sellers, advertisers, and workers on all levels of the design team (30%)

Mathematical Skills to run a business and to keep within a budget (10%)

Destination: Fashion Designer

Whether you are a jeans-and-T-shirt person or a Carrie Bradshaw type (from *Sex and the City*), the clothes you put on every day were designed by someone. A lot of thought and work goes into even the simplest item in the most low-rent shop. Even before shows like *Project Runway* became popular, fashion design was a competitive field. Everyone needs clothes and buys them regularly, and many people are eager to express themselves through clothes, and many designers have a style that appeals to

a specific group. So it's no surprise that many aspiring designers with a style and voice look to establish themselves and be the voice for a group who is hungry for great looking clothes.

Being a successful fashion designer is more than having a good sense of clothing and style. Designers keep abreast of trends and pay attention to details large and small regarding fabrics and colors. They sketch designs for both clothing and accessories, and oversee the creation of their designs from pattern to hanger. To bring their visions to life, designers depend on a foundation of skills—the ability to sew, make patterns, cut fabric, take measurements, etc.

While women's wear is and always has been the most popular design medium, designers also specialize in clothes for men and children. Some designers are so specific as to only work in casual wear, sportswear, outerwear, or maternity wear. Designers can work solely in footwear or accessories. And some master all three areas, creating an entire outfit.

A fashion designer has to think ahead and anticipate possibilities. From an initial vision to its runway debut, a clothing line will take anywhere from 18 to 24 months to create and introduce. Styles can change a lot in that short period of time, and so designers research and follow trend reports (noting what styles, colors, and fabrics will be popular in upcoming seasons). As the design is being planned, a designer will go to trade shows to get fabric samples and determine which ones will be used and how.

The next step is to create a prototype of the piece and determine what alterations need to be made. When this is done, samples are constructed and marketed to retailers at fashion and trade shows. The retailers place orders for what they like and the items are then manufactured and sent to the shops.

About a quarter of fashion designers are self-employed. Others work in design firms, such as those representing major labels. In such firms, designers are divided into categories depending on their level of experience and specialty. Entry-level designers do jobs such as patternmaking and sewing, along with some technical designing. The lead designers create the designs, choose the colors and fabrics, and oversee the technical design work. They create the prototypes and liaise with the manufacturers and suppliers during the production stages.

Other jobs for fashion designers include working for wholesalers, wherein clothes are produced for the mass market. High fashion (haute couture) design usually involves owning one's own house or store catering

to the wealthy and fashion-obsessed. Still other professionals specialize in costume design.

Prospective employers are interested in candidates with a two- or four-year degree in fine arts and a focus on fashion design. Coursework in business, marketing, and fashion merchandising is also helpful, especially if you are ultimately interested in running your own store. You must certainly be knowledgeable about textiles, fabrics, accessories, and trends.

Degree work can be done at any number of colleges, universities, and private art and design schools. Here, you study sewing, tailoring, pattern making, fashion history, textiles, computer-aided design (CAD), and design of various types of clothing. You may find it useful to take related classes in anatomy, math, and psychology as well.

To get accepted at an arts and design school or to gain employment or an internship, you have to present sketches and examples of your artistic skill and creativity. Although CAD is increasingly becoming an integral part of the design process, fine sketches are still crucial for a good portfolio. You should have these sketches ready even if you are only looking for an internship position. You can learn a lot, as well as gain valuable contacts, by applying for internships with design firms. Working in a retail shop as a personal stylist or a tailor can also teach you a lot about styles, fabrics, and tastes.

Essential Gear

Sketchbook and pencils. If you get a job as a patternmaker, you will not be drawing, but a serious consummate artist knows that inspiration can strike at any time, and you want to have your materials ready even just to outline the bare bones of an idea. You should always be ready to do your own drawing.

Employers look for a knowledge and appreciation of aesthetics. Color, detail, balance, and proportion are all concepts that should be part of a designer's everyday language. An eye for small details and color is vital. In her hilarious but pointed speech in the 2006 film *The Devil Wears Prada*, Meryl Streep's character describes a particular shade of blue on Anne Hathaway's sweater as "represent(ing) millions of dollars and countless jobs and so it's sort of comical how you think that you've made a choice that exempts you from the fashion industry when, in fact, you're wearing a sweater that was selected for you by the people in this room."

Flair and boundless creativity is crucial to good design work, but just as important, especially when starting out, are top-notch sewing and

patternmaking skills. You may not end up doing much of this work yourself, but you must know and understand exactly how they are done to enter in an intelligent discussion about garment construction.

Good personal skills are also paramount to a designer's success. You must be quick with problem-solving and engaging in presenting ideas to clients. Flexibility and teamwork are also key, because fashion design involves constant contact with suppliers, manufacturers, and worldwide buyers. It can help immensely to learn a few other languages. Even just some fashion-related polite phrases in French, Italian, and Spanish can propel you along. Fashion is international, and professionals in this field appreciate someone who makes an effort to speak their language.

While fashion is a global industry, bear in mind that most of the American designers, self-employed or not, are based in either Los Angeles or New York. If you are serious about progressing in this exciting field, you may want to consider locating yourself in one of these cities.

Fashion is a world where people constantly want the next new thing, even though it may look a lot like the last old thing. If you have the creativity, the skills, and the love of beautiful clothes necessary to compete in this arena, consider pursuing a new career in this glamorous field.

You Are Here

Do you have the basic design skills to get started in fashion?

Do you have excellent sketching, sewing, and patternmaking skills? These are the initial skills to get you started, whether in design school or on the job. Increasingly, you must be adept with computers as well in order to do computer-aided design (CAD), but sketching is still at the core of fashion design. Many designers took an interest in clothing and the human form at a young age and began drawing soon after, going on to experiment with patternmaking and then sewing. The best artists can tell you that this early experimentation is vital because you learn from mistakes. You can, of course, gain patternmaking and sewing skills later, but good design begins with sketching.

Are you creative and quick-thinking? The earlier-mentioned scene in the film *The Devil Wears Prada* shows fashion employees scrambling to improve an outfit so that it is fit to show in what is meant to be *Vogue* magazine.

Although the scene is funny, industry experts have indicated that the experience is very real. You have to be someone who thinks fast and is able to twist a design on the spot to sell it. Your overall creativity, both in working with a fashion house's designs and coming up with your own, is vital to a successful career. Employers do not want to see designs so bizarre no one would wear them. They want to see that you know how to think about the body, how it moves, and how a design looks when worn.

Do you have excellent communication skills? Fashion designers are an easy target for comedy and they often get portrayed in popular culture as snooty or insane or some combination thereof. For a better sense of the sort of personality that a successful designer should be, look to the 1995 documentary Unzipped, about designer Isaac Mizrahi. He is clearly warm and funny, as well as inventive and driven. No matter how successful you become, you still have to work with a lot of different people to get your designs out there, and you have to be able to talk and engage with them productively.

Navigating the Terrain

Where are you now, and what sort of fashion design do you hope to do?

I have worked as a personal stylist or tailor

I have good sewing and drawing skills

Build a portfolio

Take a design class to get current with trends

Look for paid costuming opportunities

Hone your skills and develop contacts with volunteer work

Organizing Your Expedition

Prepare your kit for entering the world of fashion.

Learn what the middle-income shopper likes. If you can design clothes that are stylish and yet affordable, you may not become a superstar, but you will certainly become a success. The middle-income shopper is the bread-and-butter of the fashion world, although the editors at Vogue may not always want to admit it. Designing clothes that are well made, fit nicely, and are affordable is more difficult than the average shopper knows. Tailoring your skills so that you can please the everyday shopper with beautiful but affordable clothes can build a career.

Essential Gear

Portfolio. It is what gets you in the door of either a good school or a good job opportunity. Your portfolio must demonstrate your skill, flair, and style. Take more time than you even think you need to put it together. Consult with teachers and people in the business as to its presentation and selection. Most people are happy to advise, and probably only got ahead with advice and help themselves, so they remember what it is like to be starting out. Even once you have a job, it cannot hurt to keep the portfolio with you. You never know who might stop by the studio and take an interest in seeing it.

Experiment with organic fabrics. More shoppers, from discount to couture, are interested in green fashion. Fashion is notoriously environmentally unfriendly, as dyes and synthetics, or even cotton, can be hard on the ecosystem. Additionally, the sheer amount of clothes that are manufactured and yet not sold is wasteful. Better design and manufacturing facilities are in development, as are the uses of fair trade and environmentally sound fabrics such as hemp (one of the best eco-friendly fabrics), bamboo, organic cotton, and fleece made of recycled products like plastic bottles. Unfortunately, right now most eco-conscious clothing is very expensive. However, as designers continue to experiment with fabrics, the manufacturing of these garments is getting easier and the clothes are becoming more affordable.

Enter contests. Design schools have a number of contests for students to enter, even if you are only attending a community college part-time. There are also amateur fashion design contests, to say nothing of *Project*

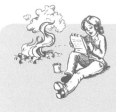

Stories from the Field

Alicia Estrada
Founder and owner of Stop Staring! Clothing
Los Angeles, California

Stop Staring!, vintage-inspired clothes for women, is rapidly growing in popularity, thanks to the design and business savvy of creator Alicia Estrada.

Estrada began sewing at 16, discovering that sharing clothes with her six sisters required regular alterations. Her mother taught her the basics, and she gradually improved and then began making her own patterns. She briefly attended the Long Beach City College Fashion Program and soon saw her vintage-inspired dresses becoming popular at a few Hollywood boutiques. She decided to try and create a full line, and a business. With the swing dance scene exploding, Estrada knew she was tapping into an important market—women wanted dresses that looked the part, but also fit well and were sturdier and easier to care for than actual vintage dresses. For the same price as a dress that would need alteration and gentle treatment, women could get dresses in modern fabrics and sizes. Estrada went one step further. Knowing that women of all sizes want to look hip and sexy, she designs many of her slinky dresses to fit plus-size women as well as the size 2s.

To improve her business skills, Estrada attended seminars given by Fashion Business Inc, which gears seminars to new apparel businesses, teaching them techniques for dealing with all aspects of the industry. "If I didn't go to FBI,"

Runway. Simply placing well in a contest can garner you attention and job offers. Potential employers are impressed by contest citations as it demonstrates your competitiveness and go-getter attitude. You should research and then enter all the contests for which you are eligible. Even if you do not place well, you can send cards to the judges afterwards, thanking them for their time and consideration. Such gestures are appreciated and might even pave the way to a job contact.

Look for a niche. Any time you hear a friend or family member complain that there is a certain article of clothing they would love but simply cannot find, that is your clue to start designing it. Chances are, thousands of others have experienced the same frustration. While designers must pay attention to trends, they should also consider the niche market. When the

Estrada says on the Fashion Business Inc. Web site, "I would have made a lot of big mistakes. I just may have lost everything." Rather, in 2005, the city of Los Angeles named her the minority businesswoman of the year.

From showing well at a few swing and rockabilly events in 1997, when each dress had been sewn by Estrada herself, Stop Staring! dresses and other clothes are now selling at specialized boutiques nationwide, as well as online via its own Web site and other vintage-oriented sites. Media attention began slowly with raves in swing dance/retro magazines *Atomic* and *Barracuda*, and is growing to the point where even fashionista Paris Hilton has been spotted in a Stop Staring! dress. Estrada has provided clothes for the tour of the Brian Setzer Orchestra and is now being approached for films. She insists, however, that she is not a costume designer. Estrada has said on several Web sites: "I'm inspired by silver screen sirens like Marilyn Monroe, Rita Hayworth, and Joan Crawford, and the collection is basically really elegant, [but] most stores have told me they consider the collection timeless, regardless of its being vintage-inspired."

Stop Staring!'s clothes can now be found in international boutiques and the company is doubling its sales every year, all thanks to Estrada's new/old designs. "In fashion, you are either a leader or a follower," Estrada says. "I decided to lead my company into the retro 1940s and 1950s and it worked. We have had such great success in this classic retro market, our sales are bursting at the seams!"

trend in good skirts and trousers is the low-rise, someone should also be putting out a line of skirts and trousers that sit on the waist. It may seem counterintuitive because you will be running against the current trends, but a sizable number of consumers want exactly what is not being offered in all the stores.

Landmarks

If you are in your twenties . . . You should definitely apply for design school as this is the fastest way to improve your skills, learn more skills, build a solid portfolio, and make contacts. While in school, look for fashion-related jobs such as retail work or custom sewing. Broaden your range as much as possible to open yourself to more job prospects.

If you are in your thirties or forties . . . If you have excellent sketching and sewing skills but have not used them in a while, take a few classes while working on a portfolio. Look for internships either paid or unpaid, as these can be a fast way of gaining a foothold and moving up in the industry.

If you are in your fifties . . . Build your portfolio and ask for informational interviews as a way of establishing contacts. Fashion can be hard to break into because few people leave once they are established, but a willingness to do anything just to get started will garner some interest, especially if you have niche ideas or an interesting expertise.

If you are over sixty . . . If you have expertise in some area of fashion already, such as writing, as well as all the requisite excellent skills, parlay your current contacts to help with your transition. Look for smaller niche markets, like designing chic clothes for women in your age bracket. They are often wealthy and still want to look smart without wearing only Chanel.

Further Resources

Fashion Business Inc. Based in Los Angeles, FBI's seminars are targeted to designers seeking to improve everything from their design techniques to business savvy. You can become a member for further benefits and there are many useful links. If you cannot attend the seminars in person, they are available as DVDs and can be purchased via their Web site. http://www.fashionbizinc.org

Fashion Institute of Technology One of the top fashion design schools in the country. Even if you cannot do a full degree program, it is worthwhile to investigate summer courses. http://www.fitnyc.edu

IQONS.com A Web site that creates a social networking community for people in all aspects of fashion design. It offers a platform and advice and resources. http://www.iqons.com

Talent Agent/ Publicist

Talent Agent/Publicist

Career Compasses

Find your route to success as an agent.

Relevant Knowledge of the business, your field of expertise, and all the people you need to know who are involved in the work your client does (20%)

Caring about your clients and their careers (10%)

Communication Skills to work well with your clients, your contacts, and everyone with whom you are constantly negotiating deals (50%)

Organizational Skills to keep track of your clients, your contacts, and all aspects of the daily work (20%)

Destination: Talent Agent/Publicist

Ari Gold from the HBO hit show *Entourage*. Jerry Maguire from the movie by the same title. Edina Monsoon from the British television show *Absolutely Fabulous*. Samantha Jones from *Sex and the City*. Talent agents and publicists are easy to spoof in films and television, although in the case of Samantha on *Sex and the City*, she was a consummate professional and good at her job, even when she did mix a little pleasure with business.

People whose job is to represent and promote famous people are easy to stereotype because the jobs demand an aggressive, often over-the-top personality. Even if you specialize in booking bands for weddings, the career can be cutthroat. You have to be assertive and persistent to get your clients, and therefore yourself, ahead.

The trick, however, to being a good agent is that you are actually personable and generous with both clients and those who hire them, even though you are pushing hard to land your client the contract. Whether you are in a small town or the heart of the entertainment industry in either New York or Los Angeles, your success is dependent upon good word of mouth from both clients and those who would hire them. It is not enough to simply get clients good jobs or provide producers with the perfect artists. You have to be someone people want to work with. You have to be the ultimate people person.

Good agents have a gift of gab. They are in the business to sell, whether their client is a dog or a megawatt star. So they have to be engaging enough to make someone pick that dog over all the other dogs. Plus, they have to please their talent to keep them using their services.

Most agents have a specialty, such as animals, children, novelty acts, bands, solo artists, theater actors, etc. This works out best for all concerned. The performer feels they can trust the agent because the agent is focused only on their particular opportunities. Producers and other employers know the agent has carefully vetted the performer and can expect only the highest quality.

While agents deal with clients and those who would hire them, public relations executives deal with clients in order to write and publish positive articles about them. The publicist is usually the one who writes the copy and then contacts the appropriate media (television, magazines, newspapers, etc.) to have it placed. So a publicist for a band will send out press releases of the band's appearances, whether in performance, signing CDs, or doing something in the community. The publicist will also give information about the band to newspapers, magazines, local radio and television stations, and Web sites so that these media outlets will in turn write an article or make mention of the band. This is cheaper and more effective than placing advertisements and will always generate more interest.

A good publicist must always be aware of the various outlets to showcase their talent, especially in the rapidly growing and changing online world. They must excel at writing copy and at convincing media to write copy about the client. This requires finesse plus persistence. Former lawyers and e-business executives often make excellent publicists, as they have perfected these techniques and are good at engaging with people.

Publicists must earn the trust of both their clients and their contacts. A client needs to feel that their publicist is giving his or her all to the job of getting the client's name seen and heard by as many people as possible. A publicist must generate interest so that when the client next performs, the performer might be guaranteed a larger audience, and, eventually, a larger contract. Many publicists give their client a monthly report of all they've been doing to generate publicity, showing them copies of press releases, articles, and a list of online and radio/television mentions.

Essential Gear

Rolodex. Although these days, it is electronic rather than paper. But you need to build a strong client and contact list and have all their information at hand at all times. You also need to be sure you update it regularly. Nothing looks more unprofessional than not having a correct current contact number and address.

A successful publicity career can hinge on organization. Professionals must keep track of every outlet to whom they send information and every mention of their client, no matter how small. They have to be aware of all upcoming events of note that their client might consider attending to generate free publicity. And they themselves need to be out there and available. A publicist who circulates and gets their name known is one who will never be short of clients.

Even on a small scale, becoming a successful talent agent or publicist is not easy. No matter how strong your negotiating skills and personality, you have to start as someone's assistant in order to learn the ropes. If you are already organized, efficient, familiar with bookkeeping and some basic accounting, you will be a hot candidate for an assistant job. In an assistant capacity, you can hone your people skills and practice dealing with a number of personality types. You also can start building your personal reputation. Because assistants are the first people clients and producers deal with, their poise and style can make an impression and lead to future work.

Most talent agents and publicists are looking to hire someone who understands negotiation and media representation. A degree or background in law, business, communication, or journalism tends to be preferred. They also want someone with good manners, a natural gift of gab, a strong sense of integrity, and an innovative style.

For aspiring agents and publicists looking to start their own business, the good news is that you can work out of your home and at your own pace. In a small market, you should contact your local Chamber of Commerce, theatrical and music schools, photographers, religious organizations, and community colleges, explaining that you are a talent agent looking for clients and places to book them. You might be surprised how quickly you can build a decent roster.

In any size market, you have to be genuine, despite the portrayals of agents and publicists in the movies and television. Most people can see when someone is putting on an act for them, and in a relationship that functions strictly on trust, that won't go far. If you take a real interest in your clients and their careers, your own career can soar.

You Are Here

Negotiate your way into work as an agent or publicist.

Do you have a specific field of interest or expertise? For agents and even publicists, it is often best to specialize and have a tight focus on the sort of people you represent and the sort of work you want to book for them. Someone involved with the fashion industry or photography might specialize in models, for example, and they will already have contacts and an understanding of how the business works. A person working in some aspect of the music industry may be well-suited for handling bands. If you know a lot about theater, you might consider working with actors. Having a strong knowledge base to begin with helps establish you with both clients and contacts.

Are you a "people person" and good judge of character? In addition to being well spoken and engaging, you have to be able to connect with both clients and contacts. If you are someone who can talk to anyone, and adjust your approach when a person is uncertain or uncomfortable,

you will do well in the business. Good agents or publicists know how to "read" people. They can tell when people are not on the up-and-up or on the fence. Then they find a way to work with them or politely disengage. You must be someone who is your client's friend and confidant as well as their public advocate, and you have to able to talk to absolutely everybody, no matter how impossible they are.

Are you polite and persistent? The two might seem contradictory, but you cannot be a good agent or publicist without being hugely persistent. You have to expect to hear the word "no" a lot, and you must have a thick skin to handle it. The best agents and publicists will handle it with grace and aplomb, but also learn to find ways that it might be turned into an eventual "yes." Most of the time, however, you simply have to push and push hard, and yet be charming and gracious so that people don't realize how hard you are prodding them. It is an art, which is why you can do best starting off as an assistant and watching a pro do the job while you learn.

Navigating the Terrain

Where are you now, and what sort of agent or publicist would you like to be?

I have applicable expertise or already work in media

Research agencies to identify a good fit

Work up application materials

Send your résumé to publicists

Organizing Your Expedition

Be prepared for the wild world of agent work and publicity.

Advertise, advertise, advertise. Every day and in every way, you have to get your name out there just as much as you have to get your clients out there. When people know you, they want to work with you, in whatever capacity you need. A new agent must advertise in local papers, Web sites, houses of worship, newsletters for appropriate organizations (such as trade magazines for restaurants) and community boards that they can book entertainment for weddings, parties, and trade shows. Maintain a Web site with a list of all your clients and their various bookings. Even if you don't have anything new to add, you should still do regular updates so that people looking at your site see that it receives regular attention.

> ## *Essential Gear*
>
> **List of all the media outlets**. You must know absolutely every source and every connected name to which to send information. A list like this may be accessed via the Web these days. You especially want to keep track of popular Web sites that might be related and therefore worth placing advertisements.

Hone your writing skills. As a publicist, and even sometimes as a talent agent, you will have to write press releases and other blurbs about your clients. There is a special technique to writing a good press release, and you only get good at it via practice. However, to do well at your job, you have to write strong, catchy copy, and you have to write it quickly. Sometimes you have to provide a press release within an hour of speaking to a media contact. This is a skill that can take several years to perfect. Most agents and publicists learn the art of writing a successful press release while working as an assistant.

Make good contacts. The name of the game as either a talent agent or publicist is knowing people and being able to work with them. A publicist wants to be on good terms with press representatives so that when they will be more inclined to get information in print or on the air. You also want to be friends with everyone so that they will come and see your client perform. Landing your clients a job and getting press is one thing, but

Notes from the Field

DeAnne Merey
President, DeAnne Merey Public Relations DM-PR.com
New York, New York

What were you doing before you decided to change careers?

I'd gone to law school and was working as a corporate lawyer.

Why did you change your career?

I found many of my colleagues to be unethical, and I didn't like the way the work was conducted. The hours were very long, meaning I was spending a lot of time with problematic people. I wanted to do something that involved creating relationships, rather than being adversarial. I wanted a career that felt kinder, more moderate, and more positive.

How did you make the transition?

I had neighbors who were in PR and that got me interested in the possibility of that kind of work. I knew I was going to have to pay dues all over again and start at the bottom, so I just sent out my résumé to every PR person in town, looking for a job as an assistant. In the end,

actually filling the seats at a gig is another. Even well-known performers will not necessarily draw in an audience. A popular, well-connected publicist sets up quid pro quo relationships that create an obligation to attend shows. On the more positive side, publicists and agents who are known to have good clients, and good clients and events often have people clamoring for tickets. Work on being the person whose events people want to attend, because they know it will be a good night out.

Landmarks

If you are in your twenties . . . You have to be realistic and understand that no one wants an agent or publicist who is too young on the theory that he or she is not yet well-connected or experienced enough. This is the time to look for an agent or publicist doing the sort of work in which

it was very serendipitous. I had sent my résumé to one publicist and then followed up a week later, the day his current assistant quit, so he hired me out of desperation. The job paid much less than my previous job had, of course, but I stuck with it for a year and then got a promotion. In all, it's been 10 years from starting all over to recently opening my own firm.

What are the keys to success in your career?

Sticking with it. You have to be able to speak to anyone. You simply can't be the least bit shy. You have to be very comfortable on the phone. You have to be aggressive, but you don't want anyone to know it. Persistence is very important. It is a very difficult job. There will always be rejections and failures, and you can't let it discourage you. After all, if it was easy, clients wouldn't need professionals to get them publicity. Honesty and integrity are important, as well as being innovative with the client. Innovation is a way to distinguish yourself. I report to my clients regularly to show them what I've done and invite their participation so that they're part of the process. It's all about relationships.

you are interested and apply to be their assistant. Being an assistant is the best way to learn the ropes.

If you are in your thirties or forties . . . You might still consider working as an assistant for a year or two, simply to get the feel of how an agency or public relations firm works. With a background in business or law or journalism, you will find that you can bring a lot of skills to the job already, but there are still techniques to learn and this is a perfect setting in which to quickly learn them.

If you are in your fifties . . . In a smaller market, with a field of expertise and a business background, you can try setting up an office with a specialty. You may want to take a class in communications or something similar to work on your all-important conversational technique.

If you are over sixty . . . If you have experience in a strongly related field, along with a set of contacts, you can set up a small office and tell your contacts that you are now doing representation. Many of them will be happy to work with you, based on their long relationship and trust in your style and ability.

Further Resources

Ross Reports Online This is a subscription service via Backstage magazine, which lists every talent agent in theater. You can use this to look for agents in an area that interests you and then either apply for jobs as their assistant or ask them for informational interviews. http://www.backstage.com/bso/rossreports/directories.jsp

Creative Marketing Solutions A blog featuring discussions about marketing strategies and innovations, including a useful FAQ page, lists of ideas, and consulting and seminar information. http://www.yudkin. com/marketing.htm

Choreographer/ Fight Director

Choreographer/ Fight Director

Career Compasses

Do the footwork to life as a choreographer.

Relevant Knowledge of the techniques used in stage combat, various kinds of dance and combat, and history of both (25%)

Caring about doing excellent, inventive work, even when you are not making much money (25%)

Organizational Skills to be able to plan and execute dance and fight choreography (25%)

Communication Skills to describe the choreography to actors and dancers and to work with directors on developing the choreography that most suits their vision (25%)

Destination: Choreographer/Fight Director

Dance numbers and onstage fights all need to be designed and staged by professional choreographers and stage combat directors, also known as fight directors or fight choreographers. Stage combat, whether with fists, guns, knives, or swords, must look real and yet also be artistic, enhancing the show in which it appears. The violence is based in reality, but carefully designed using principles and techniques so as to be safe. A dance or staged fight should support the narrative in a show. A couple

might fall in love during a dance, or a main character might die in a fight. A choreographer of dances or combat works with the director and other members of the show's production team to develop movement that fits the overall vision for the piece.

Actors, dancers, and athletes are most likely to transition into careers as choreographers or fight directors as they have already spent years learning and performing the related skills. They are more likely to understand what makes some choreography look better or have a strong impact.

Fight choreographers have often had experience in fencing, martial arts, and dance from a young age. They may take classes later in stage combat, historical fencing, a wider range of martial arts, gymnastics, and yoga. Many fight directors once assisted their teachers, supervising classes for younger students. Some advance by becoming the "fight captain" on a production. This is essentially the fight director's deputy, who runs drills, assists during rehearsals, and monitors performances.

Dance choreographers come up in much the same way, studying a variety of dance techniques from a young age, such as ballet, tap, and jazz, and being selected as a teacher's assistant as they progress. Nearly all professional choreographers, such as Agnes De Mille, Bob Fosse, and Susan Stroman were professional dancers first, spending years perfecting their art and learning what makes for an effective dance performance as part of a larger production.

If you go to a lot of theater, you see a lot of fights. It is the job of the fight director to make whatever fight you see feel fresh and real, while always adhering to the basic techniques that make for a strong and safe stage fight. Fight choreographers often find the biggest challenges in the most well-known work. The fatal encounter between Mercutio, Tybalt, and Romeo in *Romeo and Juliet* has been done probably hundreds of thousands of times since it was first performed in the sixteenth century. When a fight choreographer approaches it, the challenge is to make it somehow new, and yet still satisfy an expectant audience. Whether using swords, knives, or guns, the fight must be exciting and inventive, comprehensible and realistic. Everyone knows that Mercutio and Tybalt are going to die, but strong, inventive choreography might make their deaths feel more surprising. By the same token, the climactic battle at the end of Hamlet is one of the most familiar scenes in the world, so a choreographer coming to it in a new production has to try and reinvent the wheel while keeping to order, clarity, and time constraints.

Modern fights are not necessarily any easier to stage. The challenge for fight director J. David Brimmer in the dark comedy *The Lieutenant of Inishmore* was to create believable fights and standoffs with firearms that were tense and yet also funny. The dialogue was funny, and the actors brought their various tricks to the fights to add that humor to the violence, but it was Brimmer's job to stage their positions and movements to the strongest and most comedic effect, while never forgetting the reality of the violence the play was satirizing. Actors learn how to fake slaps and punches in drama school, but the fight director must still work with them when staging fist-fights so that they look real and yet avoid injury. Accidents will, of course, happen, but your job as a fight director is to run through techniques repeatedly, assessing possibilities and offering actors alternatives for any given problem, so that, even when someone misses a mark, they can still maintain the illusion of combat. When an onstage fight looks truly fake, the audience's emotional involvement is lost.

Essential Gear

Practice weapons. Unless you have been hired for a big Broadway show, you and the actors may work with very few props on the first day of fight rehearsals. You should have a wide selection of every practice weapon there is and always bring enough for you and the actors. Even if you have been hired as a fight captain, you should bring along your own weaponry.

Dance numbers involve different challenges, depending on the production. Many choreographers have to design beautiful dances that look more complex than they are because the dancers are predominately singers or actors. These performers may have movement training, but a choreographer cannot work with them in the same way as with professional dancers. Sometimes the music poses challenges. For the original Broadway production of Stephen Sondheim's *A Little Night Music*, choreographer Patricia Birch had her work cut out for her creating vibrant movement while working within the confines of the music. Sondheim's waltz-based score is rich and evocative, but the sheer amount of singing precludes too much dancing.

For those who love movement and have dedicated themselves to the art of powerful and effective stage movement, becoming a choreographer or combat director is a natural step. The work is competitive and

will not pay very well in most markets, but salaries can be augmented with teaching and workshops, and the rewards of seeing your designs dazzle an audience are immeasurable.

You Are Here

Choreograph your career trajectory.

Do you have extensive training in dance and combat? You may be a fine fencer or have a black belt or be a nifty tap dancer, but to become a choreographer or fight director, you have to have a wide range of expertise. Depending on what sort of dance choreography you want to do, you can be more limited. If you are currently a ballerina and only want to work for a ballet company, then by all means you should retain that focus. But for most of the movement-makers who want to work in theater, especially with competition being so stiff, you simply cannot throw yourself into the fray without having the requisite training.

Are you open-minded and good at listening and communicating? One of the biggest traps for choreographers in either capacity is to fall so much in love with their vision that they resist making adjustments for either the director or performers. Even the best-trained performers may have trouble executing a particular move for whatever reason and need to be able to talk to the choreographer about it, and they in turn must be able to listen, understand, and do whatever is necessary so that the performer is comfortable and the choreography works.

Are you creative and able to think outside the box? Choreographers of dance or combat have a unique style, but they get hired regularly because they can come up with inventive moves that play as absolutely inherent to the story and the lives and personalities of the characters. Even when working on a standard period piece, you should still be someone who can work with a director and cast to develop a fight that feels absolutely true to the interpretation and distinctive from anything an audience may have seen before.

Navigating the Terrain

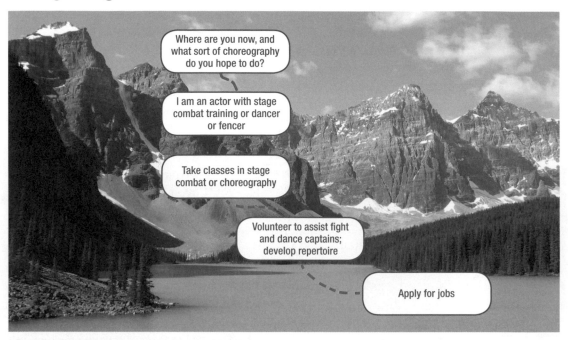

Where are you now, and what sort of choreography do you hope to do?

I am an actor with stage combat training or dancer or fencer

Take classes in stage combat or choreography

Volunteer to assist fight and dance captains; develop repertoire

Apply for jobs

Organizing Your Expedition

Fight your way to a career in movement.

Widen your area of expertise. A professional fencer is certainly a natural for segueing into fight directing, but to get ahead in this competitive field, you must also be able to work well with guns, knives, and fists. Producers and directors want to work with someone who can come up with any number of possibilities, even for what seems like standard fare. Martial arts fighting may seem like something only done on film and television, but some productions of *Henry V* have incorporated Asian styles of combat into the battle sequences, along with classic sword fighting. When a fight calls for guns and knives, it has to be big enough to be seen by those in the last row, but true enough to work for those in the fifth row, and this requires a lot of skill and understanding of the weapons and the movements.

Offer classes and workshops. Most choreographers and fight directors have to teach as a matter of course, because it is very difficult to make a living solely by choreography. However, this is also a good way to have your work seen and to make contacts. Much paid work in theater is secured via word of mouth and from whom you know. If an actor takes your class and likes it, and later goes on to produce a show that needs a choreographer, you will be called. Directors and others in theater often attend popular workshops as well. Additionally, you can work with fellow choreographers in a non-competitive space, which can lead to work down the line. It is a small community, and people call on each other for help or when they hear of opportunities. Teaching is also an excellent way for you to keep in shape and earn some money in between jobs. You can also use workshops as an opportunity to invent styles of movement, develop your personal style, and experiment with possibilities. When you are on the job, you do not have a lot of time to try a variety of stagings, so a workshop is an ideal space in which to hone your ideas.

Essential Gear

Protective gear. Whether for rigorous dances or any kind of fight, everyone needs to wear some sort of padding, and you should provide this as well. You can never go overboard when it comes to protecting the performers for whom you are choreographing. Especially during the early days of rehearsals, even the most athletic and experienced actors make mistakes when learning new movements. Because teeth guards, shin guards, kneepads, elbow pads, cups, and protective headgear may all be called for, you should have them in your bag.

Keep on fighting and dancing. Even prima ballerinas continue to take classes in between performances. You may not want to take classes while you are working, but you should look for any and every opportunity to practice your work. This can be easy for fight directors. In addition to taking other directors' workshops, a number of historical reenactment groups stage fights and fencing salles. Find a group of fighters you trust and work well with and do as much fighting as you can. Each fight you perform yourself will improve your work as a choreographer.

Engage in a lot of research. No matter what kind of fight choreography you do, you should know virtually everything about historical weaponry and fighting. It also helps to understand armor, because whatever armor

Notes from the Field
Rick Sordelet
Broadway fight director
New York, New York

One of the top fight directors in theater, Rick Sordelet started out as an actor with a background in fencing. While getting an MFA, he was told that, good as he was with fight direction, he was there to be an actor first and had to prove he could act before he was allowed to get serious about fight direction. That's advice that Sordelet passes on to anyone interested in the field. They must learn the craft of acting as well as fighting, because that's where the heart of the work is. "The tricks are only tricks," says Sordelet on the Talkin Broadway Web site. "If your character wouldn't do that, then that is all it comes off as just a trick." Sordelet works hard to stay away from tricks and delve what a character would do in real life, under real circumstances.

Sordelet spent several years teaching fighting before being tapped for regional work, and then finally his first Broadway show, *Beauty and the Beast*. He's done everything from choreograph a few quick slaps, fistfights, and elaborate warfare. While he certainly credits his fencing and martial arts skills as the base for his ability, he is quick to point out that what is most important is understanding how to translate that base into a theatrical illusion. The actors must be able to do something

fighters used at various times in history informed their movements and style of fighting. Obviously, stage combatants will not be wearing true armor, but where you can design a fight to look as though they are, it will feel stronger to the actors and read more powerfully to the audience.

Landmarks

If you are in your twenties . . . You should be engaged in as many classes as possible, widening your field of expertise and looking for fight or dance-captain work, as well as performing opportunities. If you can locate yourself in a major theater city like New York, so much the better. That is the place to be to build contacts.

that is safe for eight shows a week. Sordelet works closely with the director of a show to determine what the fight will look like. He then has what he calls a vocabulary session with the actors where he takes them through a series of moves, assessing their styles and abilities. Once he has done that, he knows what he is working with and can plan the action accordingly. He often works with actors who can't do the moves he might have originally envisioned, but he studies their strengths and enhances what they can do instead.

Although not everyone does so, Sordelet likes to have a fight call every night, meaning the fight is rehearsed before every performance. This is how he guarantees it will be fresh and safe. He admits that actors can resist this because they already know the moves. However, Sordelet points out that having the sword makes all the difference, because the sword is like a character in itself. Sordelet describes it as enhancing the character wielding it and taking on a personality of its own because of the energy it brings to the scene. It changes the tone, thus bringing a different sense of intimacy.

Ultimately, safety is Sordelet's number-one concern. From there, he wants to find what is exciting for the audience and historically accurate. He also considers what the characters would be capable of as well as what the actors can do. Some actors are better fighters than their characters, and vice-versa. Sordelet's job is to create a happy medium. His impressive work has also appeared in opera, films, and television.

If you are in your thirties or forties . . . If you are either an actor with a lot of combat experience or a dancer with a varied résumé, you should volunteer to choreograph for small venues, as well as looking for opportunities as fight/dance captains.

If you are in your fifties . . . If you are a comparatively well-known actor or athlete, you should look into establishing a teaching studio as a way of getting yourself known as an instructor and choreographer. Taking workshops with other choreographers will help them get to know you in that capacity and might lead to captain jobs.

If you are over sixty . . . There are not many fight directors in your age range, so if you are in phenomenal shape and really know your stuff, the

novelty will help you make contacts and get some work. If you spent years as a professional dancer, establishing a studio and offering some choreographic work for free initially will get your new career off the ground.

Further Resources

The Society of American Fight Directors A nonprofit membership organization dedicated to safety and excellence in the art of stage combat. Offers educational opportunities via sponsored workshops and qualified members receive certification to teach.
http://www.safd.org

The Society of Stage Directors and Choreographers This is the union site, but if you are not yet eligible for membership, you can still access news and events and contact members for information.
http://www.ssdc.org

The Complete Unarmed Stage Combat DVD Series Available from First Light Video Publishing. http://www.firstlightvideo.com

Costumer/Theatrical Wardrobe Worker

Costumer/Theatrical Wardrobe Worker

Career Compasses

Find the way to a career in wardrobe.

Relevant Knowledge of fabrics, basic sewing skills, design, lighting, sets, stage movement and practicality, anatomy, and fashion history (40%)

Organizational Skills to keep track of designs, swatches, changes, and clothes at all stages of production (20%)

Communication Skills to work with cast and crew and put over ideas and solve problems (30%)

Mathematical Skills to work well within budgets (10%)

Destination: Costumer/Theatrical Wardrobe Worker

Even at the time of the very first professional theatrical production, directors knew that dress and appearance had to be somehow different from the typical togas worn every day. Theatrical costume defines a character. It must stand out so that the actor can be seen distinctly even from the last row of the theater. Each individual costume must be unique and yet part of a cohesive whole, so that all the costumes serve the story. On a purely practical level, a costume must be comfortable for the actor

and allow for maximum movement, even if it is a tight period design. Furthermore, the costume must be easy to quickly get in and out of. It must sometimes look sumptuous and yet be of a sturdy, easily washed fabric, and designed well enough to last throughout possibly hundreds of performances. Of course, in a big-budget Broadway show, a new costume can be made as needed, but producers would always prefer not to spend that money if they do not have to.

The costume designer works with the show's producers, director, set designer, and wig stylists to devise the overall look of the wardrobe. For a large show, the costumer has a team in the wardrobe department to whom they can delegate. On a smaller show, they do just about everything. Major Broadway designers usually participate in the shows during prep and rehearsals only, costuming each performer until everyone is satisfied and the wardrobe is locked. Then they move on to their next project, and the wardrobe is maintained by the wardrobe department. When a lead character is replaced, designers usually come back to fit the new performer, but otherwise their involvement with the show is over. Designers in smaller venues not only design the clothes but often head up the wardrobe department throughout the show's run.

Large venue or small, costumers begin their work by studying the script and discussing ideas with the production team. If the play is a period piece, they research styles, fabrics, and designs. Period or modern, they then sketch initial ideas, all suited to the overall design concept of the show and the budget constraints. Once these are approved, the costumer works either alone or with a team to build, fit, and finish the costumes.

In a smaller production, the costumer does all the work of fitting and altering, as well as cleaning, ironing, and mending. For some productions, no matter what the size or period, costumes are bought or rented, rather than made. The costumer then determines what is needed, doing the buying or renting, and in the case of the latter, returning the costume at the end of the show's run.

A lot has to be considered when designing and building a costume. Stage lights can be hot, so you want to avoid heavy fabrics that do not breathe, assuring the actors' comfort. For a recent Shakespeare in the Park production of *Romeo and Juliet*, half the set was a low pool, so even white shirts had to be carefully designed so as not to become too transparent when wet. Romeo's costume required extra attention because

when he died, he lay face up in the water. A heavy layer of padding had to be discreetly inserted behind his shirt before his final scene so that the actor could lie in a few inches of water for 10 minutes without getting too cold or wet. However, it was important the padding not be seen, as this would have spoiled the illusion.

A costumer's hours can be very long. Hours of work are involved in prep and rehearsal, and then, if the costumer is also heading up the wardrobe department, they work from early evening to late at night getting the costumes ready for performance and then taking care of them after the show.

Many costumers come to the job without formal training and learn the work from the ground up, but the paying jobs, even in community theater, are highly competitive and most employers prefer to hire someone with professional qualifications. A bachelor's and even a master's degree in theater design is common. That said, if you have the requisite skills, you can also start as a wardrobe assistant and work your way up the ladder, gaining design skills and making contacts as you go. Likewise, if you have a background in fashion design or something similar, you may be able to transition directly into theatrical design. Differences in style and requirements of the two fields demand that you either take some courses in theatrical design first, or work with a professional designer initially in order to master the techniques of stage costumes.

Essential Gear

Portfolio. Combined with your show/demo reel, a portfolio is what lands you jobs, not just initially, but for several years into your career. Once you are well known, people will approach you for work and the portfolio becomes be less important. Take your time compiling the portfolio and ask the opinions and advice of people you trust whose work you like. You want to put the same care into the portfolio as you do the designs themselves.

Many practical skills are required to work in any aspect of theatrical wardrobe. You must have a strong understanding of the history of dress and fabric. You must be good at sewing, altering, and mending. You must have an excellent understanding of the human body and how to design for and dress it. Excellent drawing and painting skills are also paramount. You should be able to sketch with speed and accuracy, making your work comprehensible to those who know little about the intricacies of design.

You should understand color, dyeing, and crafts such as knitting. Some understanding of jewelry is helpful, as is an understanding of set and lighting so that you can communicate with these departments and design a cohesive visual scheme for the show. You must be well-organized, detail-oriented, and have excellent communication skills so as to work effectively with the cast and crew.

Employers want to see what you can do before they take a chance on you. A portfolio shows off your talents, but to build a strong one you may volunteer for costuming work in any venue. Additionally, you may wish to compile a demo reel of your work, which is to say, a DVD of your costumes in action. Their look in sketch form and photographs is important, but the way they look under lights and in motion is crucial.

Costuming is competitive, there can be gaps between jobs, and the pay, especially when starting out, can be low. However, for those who love performance and the ability of clothes to enhance the experience of a live show, the joys of the work are priceless.

You Are Here

Find your way into the world of theatrical clothing.

Do you love clothes and are you creative and inventive? To do good theatrical designing, you have to be highly creative, not just in terms of the thoughtful design you bring to each individual character, but also by doing brilliant work within tight budgetary and time restraints. Your designs have to feel absolutely inherent to each show. If you are doing a period piece, even standard period costumes need not only theatrical flair, but careful thought that makes the costumes unique to the show. Or, if you are designing for something like a Shakespearean production, you want to create costumes that fit the interpretation of the play. Shakespeare works well in any kind of dress, so you want to be able to put a fresh spin on it.

Do you think fast on your feet and are you a good problem-solver? In theater, anything can go wrong at any given minute all throughout the run of a show. You have to be prepared for this and rise to the challenge

every time. If something rips minutes before the curtain is due to rise, you either have to mend it immediately or figure out how to work around it. If a character spills something on the costume, you must spot clean or hide the stain in a manner that is not distracting. Or, if the show opens tomorrow and the producer suddenly wants a costume changed, you have to work with him or her, as well as the crew and the performer involved, to make that change happen.

Are you flexible, adaptable, and do you have a good attitude? You can spend days and weeks immersed in research, go over and above in your designs to create something unique and ideal for the whole cast only to have your concepts rejected or reworked. You must be the person who can shrug it off with a laugh and then get back to work, discussing the designs further with everyone and doing whatever it takes to quickly get to the approval stage so you can get on with the costuming.

Navigating the Terrain

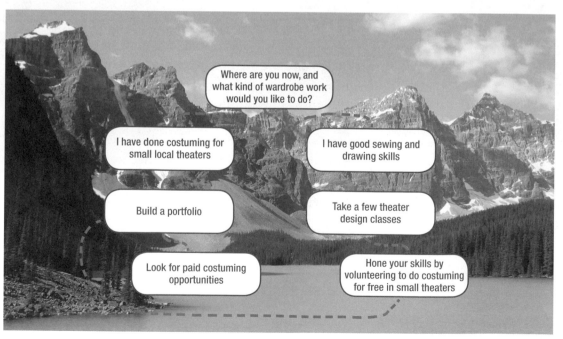

Where are you now, and what kind of wardrobe work would you like to do?

I have done costuming for small local theaters

I have good sewing and drawing skills

Build a portfolio

Take a few theater design classes

Look for paid costuming opportunities

Hone your skills by volunteering to do costuming for free in small theaters

Organizing Your Expedition

Have your sewing kit ready before you go.

Prepare a strong portfolio. The portfolio is what will sell you first and foremost. You may be full of ideas and click well with the production team in an interview, but if you do not have a good portfolio, your candidacy for the job is over. Ideally, your portfolio should show a range of sketches and photographs, combined with a demo reel of the costumes in action. You want as much variety as possible, so present your most inventive period, modern, and eclectic designs. If you have not done any designs on well-known plays in school or local productions, you can show some samples of things you would like to try, but a good percentage of your portfolio should show designs for shows that people know. In that way, they can easily assess your style and creativity. That is not to say you should not include some notes. Everyone knows who Juliet is, but if the director and actress's interpretation of her was as a smart, sexy, angry young woman who stood toe-to-toe with her father and the whole of Verona, you will want to explain that so your costume choice makes sense.

Essential Gear

Theater costume history library. Of course, for each new job, you are going to do new research, but you should amass a collection of reference books to keep handy at all times. You can flag designs you are interested in, make notes, and use the books for teaching your assistants and consulting with the production team.

Rack up a lot of experience. It is not enough to design and work in wardrobe for a lot of productions while you are in school, even if you graduate at the top of your class. While it certainly helps your portfolio, and you may land a paying job as a wardrobe assistant right out of school, the better candidate is one who has had some real-life experience. Shows done in an educational environment don't have quite the same "walking-a-tightrope-without-a-net" quality that characterizes live professional theater. You should volunteer for as many opportunities as you can. Amateur theaters always need more assistants, and you can gain valuable experience and make contacts. You can and should also volunteer yourself as an assistant in a larger venue. People

Stories from the Field

William Ivey Long
Broadway costume designer
New York, New York

One of Broadway's top costumers, nominated for ten Tony Awards and winner of five, William Ivey Long was born into a theatrical and academic family. Planning to become a professor like his father, he was hard at work pursuing a Ph.D. in history before he was urged to apply to Yale's design program. It was only natural, as he had had an interest in costume since he was six, when he made an Elizabethan ruff for his dog. But when he was at Yale, his focus was not on costumes, but on sets.

When he graduated and moved to New York in 1975, however, he got into clothing, spending three years as an unpaid apprentice to couturier Charles James. He supported himself by designing dolls. In 1978, a friend recommended him to do the costume designs for *The Inspector General.* He has since been inducted into the American Theatre Hall of Fame, having done 50 Broadway shows, and is hailed as a designer of immense wit and inventiveness.

Long brims over with ideas and is meticulous in his attention to detail. He knows inspiration can come from anywhere. One of the costumes he designed for Hairspray started off as a pink plastic shower curtain. And while many of his costumes are wonderfully eye-popping, he is widely credited as always putting the show first. His costumes do not upstage the story.

are always impressed with someone who is willing to work for free, acknowledging that, although they certainly have talent and skill, they also have a lot to learn and this is the best way to get that education. Again, it is a great way to make those all-important contacts. If you impress people with your talent, abilities, and attitude while working for free, you are that much more likely to be offered a paying job when one next comes up.

Learn all about lighting, set design, and basic numbers. If you get a degree in theater, you take courses in technical aspects of stage work. The

Long's style of design is all about defining the character. He prefers projects that are original because he doesn't like to know what someone else once wore in a role. He likes to let his thought process begin after the director indicates the theme and preliminary ideas for the show. When the team meets for the second time, that is when Long starts to bring ideas and work on thumbnail sketches and collages. By the third meeting, he's nearly done and ready to start having a give-and-take with the actors.

Throughout his career, there have certainly been disasters, like the time Mary Tyler Moore quit a show and Long had to see that the understudy had clothes that were stage-ready. He is philosophic about such problems. "The trick about the theater," he said in the *New York Times*, "is that at the end of the day, you cannot take any of it personally."

Long is one of the busiest designers on Broadway, to the point where one of the few criticisms anyone can give him is that he takes on too much. He continues to pay attention to his costumes in touring productions, noting that *Chicago* alone has kept him busy both on Broadway and on the road for 10 years. He also finds time for altruism, having founded the nonprofit Eastern Seaboard Trust to encourage economic development in his birthplace. He also lends historical clothing to Off Broadway shows that otherwise could not afford such good costumes, restores houses, and is deeply involved in job creation studies in North Carolina.

better you understand styles and mechanics of lighting and set design, the better a costumer you will be. You work as a team with the lighting and set design crew to develop a color and style palette for a show, so if you have some good basic knowledge of the kind of lights used and the effect they have on certain fabrics and colors, you can communicate far more effectively. You must be very strong at working well within a budget and finding ways to make costumes look richer than they are. You always want to keep the costs of everything in mind—not just what's involved in making the clothes, but also maintaining them. Getting a reputation as a good budgeter will do wonders for your career.

Landmarks

If you are in your twenties . . . If you do not have a degree in theater design, you should at least take some classes while volunteering for as many wardrobe opportunities as you can find. You are in a good position to slowly work your way up the ladder doing wardrobe work, but you will progress more quickly with coursework behind you.

If you are in your thirties or forties . . . A refresher course might not be a bad idea as you prepare your portfolio. If you have not done any practical experience since your degree, you should volunteer for a few projects as you also apply for paid wardrobe work.

If you are in your fifties . . . If you are transitioning from a clothing-related job such as fashion design or professional tailoring, you should look for costuming opportunities in smaller venues while taking one or two classes in theater design.

If you are over sixty . . . If you have been working in a related field or have a specialty, like beading, or period clothes (perhaps you have built or designed for a reproduction house), you can look for wardrobe opportunities in larger venues while building up your portfolio.

Further Resources

Resources from ArtsLynx Comprehensive Web site full of links to other useful costume resource pages. Features articles on all aspects of theater and theater design. http://www.artslynx.org/theatre/descost.htm
Fashion Institute of Design and Merchandising One of the premier design schools in the country, FIDM also has a useful Web site with online galleries to view costumes. http://www.fidm.edu
The Costume Gallery Shows costumes from some famous designers and offers links and other research materials for aspiring designers. http://www.costumegallery.com

Appendix A

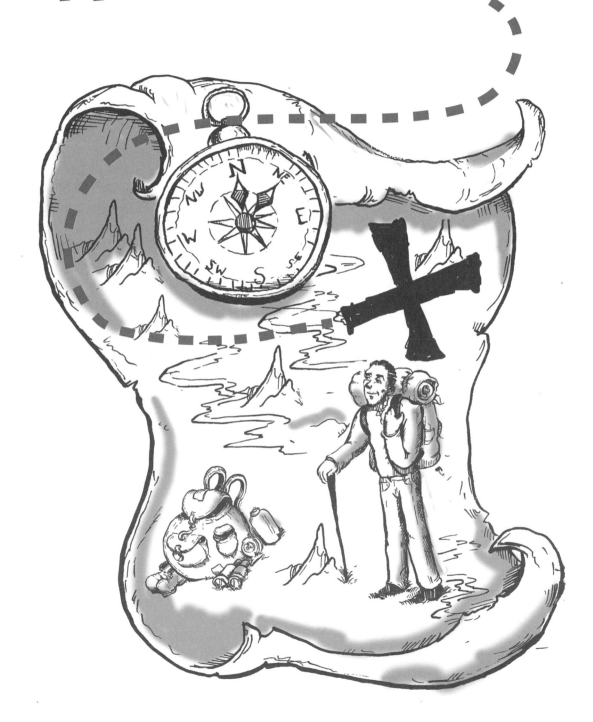

Going Solo: Starting Your Own Business

Starting your own business can be very rewarding—not only in terms of potential financial success, but also in the pleasure derived from building something from the ground up, contributing to the community, being your own boss, and feeling reasonably in control of your fate. However, business ownership carries its own obligations—both in terms of long hours of hard work and new financial and legal responsibilities. If you succeed in growing your business, your responsibilities only increase. Many new business owners come in expecting freedom only to find themselves chained tighter to their desks than ever before. Still, many business owners find greater satisfaction in their career paths than do workers employed by others.

The Internet has also changed the playing field for small business owners, making it easier than ever before to strike out on your own. While small mom-and-pop businesses such as hairdressers and grocery stores have always been part of the economic landscape, the Internet has made reaching and marketing to a niche easier and more profitable. This has made possible a boom in *microbusinesses*. Generally, a microbusiness is considered to have under ten employees. A microbusiness is also sometimes called a *SoHo* for "small office/home office."

The following appendix is intended to explain, in general terms, the steps in launching a small business, no matter whether it is selling your Web-design services or opening a pizzeria with business partners. It will also point out some of the things you will need to bear in mind. Remember also that the particular obligations of your municipality, state, province, or country may vary, and that this is by no means a substitute for doing your own legwork. Further suggested reading is listed at the end.

Crafting a Business Plan

It has often been said that success is 1 percent inspiration and 99 percent perspiration. However, the interface between the two can often be hard to achieve. The first step to taking your idea and making it reality is constructing a viable *business plan*. The purpose of a business plan is to think things all the way through, to make sure your ideas really are

profitable, and to figure out the "who, what, when, where, why, and how" of your business. It fills in the details for three areas: your goals, why you think they are attainable, and how you plan to get to there. "You need to know where you're going before you take that first step," says Drew Curtis, successful Internet entrepreneur and founder of the popular newsfilter Fark.com.

Take care in writing your business plan. Generally, these documents contain several parts: An *executive summary* stating the essence of the plan; a *market summary* explaining how a need exists for the product and service you will supply and giving an idea of potential profitability by comparing your business to similar organizations; a *company description* which includes your products and services, why you think your organization will succeed, and any special advantages you have, as well as a description of *organization* and *management*; and your *marketing and sales strategy*. This last item should include market highlights and demographic information and trends that relate to your proposal. Also include a *funding request* for the amount of start-up capital you will need. This is supported by a section on *financials*, or the sort of cash flow you can expect, based on market analysis, projection, and comparison with existing companies. Other needed information, such as personal financial history, résumés, legal documents, or pictures of your product, can be placed in *appendices*.

Use your business plan to get an idea of how much startup money is necessary and to discipline your thinking and challenge your preconceived notions before you develop your cash flow. The business plan will tell you how long it will take before you turn a profit, which in turn is linked to how long it will before you will be able to pay back investors or a bank loan—which is something that anyone supplying you with money will want to know. Even if you are planning to subside on grants or you are not planning on investment or even starting a for-profit company, the discipline imposed by the business plan is still the first step to organizing your venture.

A business plan also gives you a realistic view of your personal financial obligations. How long can you afford to live without regular income? How are you going to afford medical insurance? When will your business begin turning a profit? How much of a profit? Will you need to reinvest your profits in the business, or can you begin living off of them? Proper planning is key to success in any venture.

A final note on business plans: Take into account realistic expected profit minus realistic costs. Many small business owners begin by underestimating start-ups and variable costs (such as electricity bills), and then underpricing their product. This effectively paints them into a corner from which it is hard to make a profit. Allow for realistic market conditions on both the supply and the demand side.

Partnering Up

You should think long and hard about the decision to go into business with a partner (or partners). Whereas other people can bring needed capital, expertise, and labor to a business, they can also be liabilities. The questions you need to ask yourself are:

☞ Will this person be a full and equal partner? In other words, are they able to carry their own weight? Make a full and fair assessment of your potential partner's personality. Going into business with someone who lacks a work ethic, or prefers giving directions to working in the trenches, can be a frustrating experience.

☞ What will they contribute to the business? For instance, a partner may bring in start-up money, facilities, or equipment. However, consider if this is enough of a reason to bring them on board. You may be able to get the same advantages in another way—for instance, renting a garage rather than working out of your partner's. Likewise, doubling skill sets does not always double productivity.

☞ Do they have any liabilities? For instance, if your prospective partner has declared bankruptcy in the past, this can hurt your collective venture's ability to get credit.

☞ Will the profits be able to sustain all the partners? Many start-up ventures do not turn profits immediately, and what little they do produce can be spread thin amongst many partners. Carefully work out the math.

Also bear in mind that going into business together can put a strain on even the best personal relationships. No matter whether it is family, friends, or strangers, keep everything very professional with written agreements regarding these investments. Get everything in writing, and be clear where obligations begin and end. "It's important to go into

business with the right people," says Curtis. "If you don't—if it degrades into infighting and petty bickering—it can really go south quickly."

Incorporating. . . or Not

Think long and hard about incorporating. Starting a business often requires a fairly large—and risky—financial investment, which in turn exposes you to personal liability. Furthermore, as your business grows, so does your risk. Incorporating can help you shield yourself from this liability. However, it also has disadvantages.

To begin with, incorporating is not necessary for conducting professional transactions such as obtaining bank accounts and credit. You can do this as a sole proprietor, partnership, or simply by filing a DBA ("doing business as") statement with your local court (also known as "trading as" or an "assumed business name"). The DBA is an accounting entity that facilitates commerce and keeps your business' money separate from your own. However, the DBA does not shield you from responsibility if your business fails. It is entirely possible to ruin your credit, lose your house, and have your other assets seized in the unfortunate event of bankruptcy.

The purpose of incorporating is to shield yourself from personal financial liability. In case the worst happens, only the business' assets can be taken. However, this is not always the best solution. Check your local laws: Many states have laws that prevent a creditor from seizing a non-incorporated small business' assets in case of owner bankruptcy. If you are a corporation, however, the things you use to do business that are owned by the corporation—your office equipment, computers, restaurant refrigerators, and other essential equipment—may be seized by creditors, leaving you no way to work yourself out of debt. This is why it is imperative to consult with a lawyer.

There are other areas in which being a corporation can be an advantage, such as business insurance. Depending on your business needs, insurance can be for a variety of things: malpractice, against delivery failures or spoilage, or liability against defective products or accidents. Furthermore, it is easier to hire employees, obtain credit, and buy health insurance as an organization than as an individual. However, on the downside, corporations are subject to specific and strict laws concerning management and ownership. Again, you should consult with a knowledgeable legal expert.

Among the things you should discuss with your legal expert are the advantages and disadvantages of incorporating in your jurisdiction and which type of incorporation is best for you. The laws on liability and how much of your profit will be taken away in taxes vary widely by state and country. Generally, most small businesses owners opt for *limited liability companies* (LLCs), which gives them more control and a more flexible management structure. (Another possibility is a *limited liability partnership*, or *LLP*, which is especially useful for professionals such as doctors and lawyers.) Finally, there is the *corporation*, which is characterized by transferable ownerships shares, perpetual succession, and, of course, limited liability.

Most small businesses are sole proprietorships, partnerships, or privately-owned corporations. In the past, not many incorporated, since it was necessary to have multiple owners to start a corporation. However, this is changing, since it is now possible in many states for an individual to form a corporation. Note also that the form your business takes is usually not set in stone: A sole proprietorship or partnership can switch to become an LLC as it grows and the risks increase; furthermore, a successful LLC can raise capital by changing its structure to become a corporation and selling stock.

Legal Issues

Many other legal issues besides incorporating (or not) need to be addressed before you start your business. It is impossible to speak directly to every possible business need in this brief appendix, since regulations, licenses, and health and safety codes vary by industry and locality. A restaurant in Manhattan, for instance, has to deal not only with the usual issues such as health inspectors, the state liquor board, but obscure regulations such as New York City's cabaret laws, which prohibit dancing without a license in a place where alcohol is sold. An asbestos-abatement company, on the other hand, has a very different set of standards it has to abide by, including federal regulations. Researching applicable laws is part of starting up any business.

Part of being a wise business owner is knowing when you need help. There is software available for things like bookkeeping, business plans, and Web site creation, but generally, consulting with a knowledgeable professional—an accountant or a lawyer (or both)—is the smartest move. One of the most common mistakes is believing that just because

you have expertise in the technical aspects of a certain field, you know all about running a business in that field. Whereas some people may balk at the expense, by suggesting the best way to deal with possible problems, as well as cutting through red tape and seeing possible pitfalls that you may not even have been aware of, such professionals usually more than make up for their cost. After all, they have far more experience at this than does a first-time business owner!

Financial

Another necessary first step in starting a business is obtaining a bank account. However, having the account is not as important as what you do with it. One of the most common problems with small businesses is undercapitalization—especially in brick-and-mortar businesses that sell or make something, rather than service-based businesses. The rule of thumb is that you should have access to money equal to your first year's anticipated profits, plus start-up expenses. (Note that this is not the same as having the money on hand—see the discussion on lines of credit, below.) For instance, if your annual rent, salaries, and equipment will cost $50,000 and you expect $25,000 worth of profit in your first year, you should have access to $75,000 worth of financing.

You need to decide what sort of financing you will need. Small business loans have both advantages and disadvantages. They can provide critical start-up credit, but in order to obtain one, your personal credit will need to be good, and you will, of course, have to pay them off with interest. In general, the more you and your partners put into the business yourselves, the more credit lenders will be willing to extend to you.

Equity can come from your own personal investment, either in cash or an equity loan on your home. You may also want to consider bringing on partners—at least limited financial partners—as a way to cover start-up costs.

It is also worth considering obtaining a line of credit instead of a loan. A loan is taken out all at once, but with a line of credit, you draw on the money as you need it. This both saves you interest payments and means that you have the money you need when you need it. Taking out too large of a loan can be worse than having no money at all! It just sits there collecting interest—or, worse, is spent on something utterly unnecessary—and then is not around when you need it most.

The first five years are the hardest for any business venture; your venture has about double the usual chance of closing in this time (1 out of 6, rather than 1 out of 12). You will probably have to tighten your belt at home, as well as work long hours and keep careful track of your business expenses. Be careful with your money. Do not take unnecessary risks, play it conservatively, and always keep some capital in reserve for emergencies. The hardest part of a new business, of course, is the learning curve of figuring out what, exactly, you need to do to make a profit, and so the best advice is to have plenty of savings—or a job to provide income—while you learn the ropes.

One thing you should not do is count on venture capitalists or "angel investors," that is, businesspeople who make a living investing on other businesses in the hopes that their equity in the company will increase in value. Venture capitalists have gotten something of a reputation as indiscriminate spendthrifts due to some poor choices made during the dot-com boom of the late 1990s, but the fact is that most do not take risks on unproven products. Rather, they are attracted to young companies that have the potential to become regional or national powerhouses and give better-than-average returns. Nor are venture capitalists are endless sources of money; rather, they are savvy businesspeople who are usually attracted to companies that have already experienced a measure of success. Therefore, it is better to rely on your own resources until you have proven your business will work.

Bookkeeping 101

The principles of double-entry bookkeeping have not changed much since its invention in the fifteenth century: one column records debits, and one records credits. The trick is *doing* it. As a small business owner, you need to be disciplined and meticulous at recording your finances. Thankfully, today there is software available that can do everything from tracking payables and receivables to running checks and generating reports.

Honestly ask yourself if you are the sort of person who does a good job keeping track of finances. If you are not, outsource to a bookkeeping company or hire someone to come in once or twice a week to enter invoices and generate checks for you. Also remember that if you have employees or even freelancers, you will have to file tax forms for them at the end of the year.

Another good idea is to have an accountant for your business to handle advice and taxes (federal, state, local, sales tax, etc.). In fact, consulting with an a certified public accountant is a good idea in general, since they are usually aware of laws and rules that you have never even heard of.

Finally, keep your personal and business accounting separate. If your business ever gets audited, the first thing the IRS looks for is personal expenses disguised as business expenses. A good accountant can help you to know what are legitimate business expenses. Everything you take from the business account, such as payroll and reimbursement, must be recorded and classified.

Being an Employer

Know your situation regarding employees. To begin with, if you have any employees, you will need an Employer Identification Number (EIN), also sometimes called a Federal Tax Identification Number. Getting an EIN is simple: You can fill out IRS form SS-4, or complete the process online at http://www.irs.gov.

Having employees carries other responsibilities and legalities with it. To begin with, you will need to pay payroll taxes (otherwise known as "withholding") to cover income tax, unemployment insurance, Social Security, and Medicare, as well as file W-2 and W-4 forms with the government. You will also be required to pay workman's compensation insurance, and will probably also want to find medical insurance. You are also required to abide by your state's nondiscrimination laws. Most states require you to post nondiscrimination and compensation notices in a public area.

Many employers are tempted to unofficially hire workers "off the books." This can have advantages, but can also mean entering a legal gray area. (Note, however, this is different from hiring freelancers, a temp employed by another company, or having a self-employed professional such as an accountant or bookkeeper come in occasionally to provide a service.) It is one thing to hire the neighbor's teenage son on a one-time basis to help you move some boxes, but quite another to have full-time workers working on a cash-and-carry basis. Regular wages must be noted in the accounts, and gaps may be questioned in the event of an audit. If the workers are injured on the job, you are not covered by

workman's comp, and are thus vulnerable to lawsuits. If the workers you hired are not legal residents, you can also be liable for civil and criminal penalties. In general, it is best to keep your employees as above-board as possible.

Building a Business

Good business practices are essential to success. First off, do not overextend yourself. Be honest about what you can do and in what time frame. Secondly, be a responsible business owner. In general, if there is a problem, it is best to explain matters honestly to your clients than to leave them without word and wondering. In the former case, there is at least the possibility of salvaging your reputation and credibility.

Most business is still built by personal contacts and word of mouth. It is for this reason that maintaining your list of contacts is an essential practice. Even if a particular contact may not be useful at a particular moment, a future opportunity may present itself—or you may be able to send someone else to them. Networking, in other words, is as important when you are the boss as when you are looking for a job yourself. As the owner of a company, having a network means getting services on better terms, knowing where to go if you need help with a particular problem, or simply being in the right place at the right time to exploit an opportunity. Join professional organizations, the local Chamber of Commerce, clubs and community organizations, and learn to play golf. And remember—never burn a bridge.

Advertising is another way to build a business. Planning an ad campaign is not as difficult as you might think: You probably already know your media market and business community. The trick is applying it. Again, go with your instincts. If you never look twice at your local weekly, other people probably do not, either. If you are in a high-tourist area, though, local tourists maps might be a good way to leverage your marketing dollar. Ask other people in your area or market who have business similar to your own. Depending on your focus, you might want to consider everything from AM radio or local TV networks, to national trade publications, to hiring a PR firm for an all-out blitz. By thinking about these questions, you can spend your advertising dollars most effectively.

Nor should you underestimate the power of using the Internet to build your business. It is a very powerful tool for small businesses, potentially reaching vast numbers of people for relatively little outlay of money. Launching a Web site has become the modern equivalent of hanging out your shingle. Even if you are primarily a brick-and-mortar business, a Web presence can still be an invaluable tool—your store or offices will show up on Google searches, plus customers can find directions to visit you in person. Furthermore, the Internet offers the small-business owner many useful tools. Print and design services, order fulfillment, credit card processing, and networking—both personal and in terms of linking to other sites—are all available online. Web advertising can be useful, too, either by advertising on specialty sites that appeal to your audience, or by using services such as Google AdWords.

Amateurish print ads, TV commercials, and Web sites do not speak well of your business. Good media should be well-designed, well-edited, and well-put together. It need not, however, be expensive. Shop around and, again, use your network.

Flexibility is also important. "In general, a business must adapt to changing conditions, find new customers and find new products or services that customers need when the demand for their older products or services diminishes," says James Peck, a Long Island, New York, entrepreneur. In other words, if your original plan is not working out, or if demand falls, see if you can parlay your experience, skills, and physical plant into meeting other needs. People are not the only ones who can change their path in life; organizations can, too.

A Final Word

In business, as in other areas of life, the advice of more experienced people is essential. "I think it really takes three businesses until you know what you're doing," Drew Curtis confides. "I sure didn't know what I was doing the first time." Listen to what others have to say, no matter whether it is about your Web site or your business plan. One possible solution is seeking out a mentor, someone who has previously launched a successful venture in this field. In any case, before taking any step, ask as many people as many questions as you can. Good advice is invaluable.

Further Resources

American Independent Business Alliance
http://www.amiba.net

American Small Business League
http://www.asbl.com

IRS Small Business and Self-Employed One-Stop Resource
http://www.irs.gov/businesses/small/index.html

The Riley Guide: Steps in Starting Your Own Business
http://www.rileyguide.com/steps.html

Small Business Administration
http://www.sba.gov

Appendix B

Outfitting Yourself for Career Success

As you contemplate a career shift, the first component is to assess your interests. You need to figure out what makes you tick, since there is a far greater chance that you will enjoy and succeed in a career that taps into your passions, inclinations, natural abilities, and training. If you have a general idea of what your interests are, you at least know in which direction you want to travel. You may know you want to simply switch from one sort of nursing to another, or change your life entirely and pursue a dream you have always held. In this case, you can use a specific volume of The Field Guides to Finding a New Career to discover which position to target. If you are unsure of your direction you want to take, well, then the entire scope of the series is open to you! Browse through to see what appeals to you, and see if it matches with your experience and abilities.

The next step you should take is to make a list—do it once in writing—of the skills you have used in a position of responsibility that transfer to the field you are entering. People in charge of interviewing and hiring may well understand that the skills they are looking for in a new hire are used in other fields, but you must spell it out. Most job descriptions are partly a list of skills. Map your experience into that, and very early in your in contacts with a prospective employer explicitly address how you acquired your relevant skills. Pick a relatively unimportant aspect of the job to be your ready answer for where you would look forward to learning within the organization, if this seems essentially correct. When you transfer into a field, softly acknowledge a weakness while relating your readiness to learn, but never lose sight of the value you offer both in your abilities and in the freshness of your perspective.

Energy and Experience

The second component in career-switching success is energy. When Jim Fulmer was 61, he found himself forced to close his piano-repair business. However, he was able to parlay his knowledge of music, pianos, and the musical instruments industry into another job as a sales representative for a large piano manufacturer, and quickly built up a clientele of musical-instrument retailers throughout the East Coast. Fulmer's experience

highlights another essential lesson for career-changers: There are plenty of opportunities out there, but jobs will not come to you—especially the career-oriented, well-paying ones. You have to seek them out.

Jim Fulmer's case also illustrates another important point: Former training and experience can be a key to success. "Anyone who has to make a career change in any stage of life has to look at what skills they have acquired but may not be aware of," he says. After all, people can more easily change into careers similar to the ones they are leaving. Training and experience also let you enter with a greater level of seniority, provided you have the other necessary qualifications. For instance, a nurse who is already experienced with administering drugs and their benefits and drawbacks, and who is also graced with the personality and charisma to work with the public, can become a pharmaceutical company sales representative.

Unlock Your Network

The next step toward unlocking the perfect job is networking. The term may be overused, but the idea is as old as civilization. More than other animals, humans need one another. With the Internet and telephone, never in history has it been easier to form (or revive) these essential links. One does not have to gird oneself and attend reunion-type events (though for many this is a fine tactic)—but keep open to opportunities to meet people who may be friendly to you in your field. Ben Franklin understood the principal well—*Poor Richard's Almanac* is something of a treatise on the importance or cultivating what Franklin called "friendships" with benefactors. So follow in the steps of the founding fathers and make friends to get ahead. Remember: helping others feels good; it's often the receiving that gets a little tricky. If you know someone particularly well-connected in your field, consider tapping one or two less important connections first so that you make the most of the important one. As you proceed, keep your strengths foremost in your mind because the glue of commerce is mutual interest.

Eighty percent of job openings are *never advertised*, and, according to the U.S. Bureau of Labor statistics, more than half all employees landed their jobs through networking. Using your personal contacts is far more

efficient and effective than trusting your résumé to the Web. On the Web, an employer needs to sort through tens of thousands—or millions—of résumés. When you direct your application to one potential employer, you are directing your inquiry to one person who already knows you. The personal touch is everything: Human beings are social animals, programmed to "read" body language; we are naturally inclined to trust those we meet in person, or who our friends and coworkers have recommended. While Web sites can be useful (for looking through help-wanted ads, for instance), expecting employers to pick you out of the slush pile is as effective as throwing your résumé into a black hole.

Do not send your résumé out just to make yourself feel like you're doing something. The proper way to go about things is to employ discipline and order, and then to apply your charm. Begin your networking efforts by making a list of people you can talk to: colleagues, coworkers, and supervisors, people you have had working relationship with, people from church, athletic teams, political organizations, or other community groups, friends, and relatives. You can expand your networking opportunities by following the suggestions in each chapter of the volumes. Your goal here is not so much to land a job as to expand your possibilities and knowledge: Though the people on your list may not be in the position to help you themselves, they might know someone who is. Meeting with them might also help you understand traits that matter and skills that are valued in the field in which you are interested. Even if the person is a potential employer, it is best to phrase your request as if you were seeking information: "You might not be able to help me, but do you know someone I could talk to who could tell me more about what it is like to work in this field?" Being hungry gives one impression, being desperate quite another.

Keep in mind that networking is a two-way street. If you meet someone who had an opening that is not right for you, but if you could recommend someone else, you have just added to your list two people who will be favorably disposed toward you in the future. Also, bear in mind that *you* can help people in *your* old field, thus adding to your own contacts list.

Networking is especially important to the self-employed or those who start their own businesses. Many people in this situation begin because they either recognize a potential market in a field that they are familiar with, or because full-time employment in this industry is no longer a

possibility. Already being well-established in a field can help, but so can asking connections for potential work and generally making it known that you are ready, willing, and able to work. Working your professional connections, in many cases, is the *only* way to establish yourself. A freelancer's network, in many cases, is like a spider's web. The spider casts out many strands, since he or she never knows which one might land the next meal.

Dial-Up Help

In general, it is better to call contacts directly than to e-mail them. E-mails are easy for busy people to ignore or overlook, even if they do not mean to. Explain your situation as briefly as possible (see the discussion of the "elevator speech"), and ask if you could meet briefly, either at their office or at a neutral place such as a café. (Be sure that you pay the bill in such a situation—it is a way of showing you appreciate their time and effort.) If you get someone's voicemail, give your "elevator speech" and then say you will call back in a few days to follow up—and then do so. If you reach your contact directly and they are too busy to speak or meet with you, make a definite appointment to call back at a later date. Be persistent, but not annoying.

Once you have arranged a meeting, prep yourself. Look at industry publications both in print and online, as well as news reports (here, GoogleNews, which lets you search through online news reports, can be very handy). Having up-to-date information on industry trends shows that you are dedicated, knowledgeable, and focused. Having specific questions on employers and requests for suggestions will set you apart from the rest of the job-hunting pack. Knowing the score—for instance, asking about the value of one sort of certification instead of another—pegs you as an "insider," rather than a dilettante, someone whose name is worth remembering and passing along to a potential employer.

Finally, set the right mood. Here, a little self-hypnosis goes a long way: Look at yourself in the mirror, and tell yourself that you are an enthusiastic, committed professional. Mood affects confidence and performance. Discipline your mind so you keep your perspective and self-respect. Nobody wants to hire someone who comes across as insincere,

tells a sob story, or is still in the doldrums of having lost their previous job. At the end of any networking meeting, ask for someone else who might be able to help you in your journey to finding a position in this field, either with information or a potential job opening.

Get a Lift

When you meet with a contact in person (as well as when you run into anyone by chance who may be able to help you), you need an "elevator speech" (so-named because it should be short enough to be delivered during an elevator ride from a ground level to a high floor). This is a summary in which, in less than two minutes, you give them a clear impression of who you are, where you come from, your experience and goals, and why you are on the path you are on. The motto above Plato's Academy holds true: Know Thyself (this is where our Career Compasses and guides will help you). A long and rambling "elevator story" will get you nowhere. Furthermore, be positive: Neither a sad-sack story nor a tirade explaining how everything that went wrong in your old job is someone else's fault will get you anywhere. However, an honest explanation of a less-than-fortunate circumstance, such as a decline in business forcing an office closing, needing to change residence to a place where you are not qualified to work in order to further your spouse's career, or needing to work fewer hours in order to care for an ailing family member, is only honest.

An elevator speech should show 1) you know the business involved; 2) you know the company; 3) you are qualified (here, try to relate your education and work experience to the new situation); and 4) you are goal-oriented, dependable, and hardworking. Striking a balance is important; you want to sound eager, but not overeager. You also want to show a steady work experience, but not that you have been so narrowly focused that you cannot adjust. Most important is emphasizing what you can do for the company. You will be surprised how much information you can include in two minutes. Practice this speech in front of a mirror until you have the key points down perfectly. It should sound natural, and you should come across as friendly, confident, and assertive. Finally, remember eye contact! Good eye contact needs to be part of your presentation, as well as your everyday approach when meeting potential employers and leads.

Get Your Résumé Ready

Everyone knows what a résumé is, but how many of us have really thought about how to put one together? Perhaps no single part of the job search is subject to more anxiety—or myths and misunderstandings—than this 8 1/2-by-11-inch sheet of paper.

On the one hand, it is perfectly all right for someone—especially in certain careers, such as academia—to have a résumé that is more than one page. On the other hand, you do not need to tell a future employer *everything*. Trim things down to the most relevant; for a 40-year-old to mention an internship from two decades ago is superfluous. Likewise, do not include irrelevant jobs, lest you seem like a professional career-changer.

Tailor your descriptions of your former employment to the particular position you are seeking. This is not to say you should lie, but do make your experience more appealing. If the job you're looking for involves supervising other people, say if you have done this in the past; if it involves specific knowledge or capabilities, mention that you possess these qualities. In general, try to make your past experience seem as similar to what you are seeking.

The standard advice is to put your Job Objective at the heading of the résumé. An alternative to this is a Professional Summary, which some recruiters and employers prefer. The difference is that a Job Objective mentions the position you are seeking, whereas a Professional Summary mentions your background (e.g. "Objective: To find a position as a sales representative in agribusiness machinery" versus "Experienced sales representative; strengths include background in agribusiness, as well as building team dynamics and market expansion"). Of course, it is easy to come up with two or three versions of the same document for different audiences.

The body of the résumé of an experienced worker varies a lot more than it does at the beginning of your career. You need not put your education or your job experience first; rather, your résumé should emphasize your strengths. If you have a master's degree in a related field, that might want to go before your unrelated job experience. Conversely, if too much education will harm you, you might want to bury that under the section on professional presentations you have given that show how good you are at communicating. If you are currently enrolled in a course or other professional development, be sure to note this (as well as your date of expected graduation). A résumé is a study of blurs, highlights,

and jewels. You blur everything you must in order to fit the description of your experience to the job posting. You highlight what is relevant from each and any of your positions worth mentioning. The jewels are the little headers and such—craft them, since they are what is seen first.

You may also want to include professional organizations, work-related achievements, and special abilities, such as your fluency in a foreign language. Also mention your computer software qualifications and capabilities, especially if you are looking for work in a technological field or if you are an older job-seeker who might be perceived as behind the technology curve. Including your interests or family information might or might not be a good idea—no one really cares about your bridge club, and in fact they might worry that your marathon training might take away from your work commitments, but, on the other hand, mentioning your golf handicap or three children might be a good idea if your potential employer is an avid golfer or is a family woman herself.

You can either include your references or simply note, "References available upon request." However, be sure to ask your references' permission to use their names and alert them to the fact that they may be contacted before you include them on your résumé! Be sure to include name, organization, phone number, and e-mail address for each contact.

Today, word processors make it easy to format your résumé. However, beware of prepackaged résumé "wizards"—they do not make you stand out in the crowd. Feel free to strike out on your own, but remember the most important thing in formatting a résumé is consistency. Unless you have a background in typography, do not get too fancy. Finally, be sure to have someone (or several people!) read your résumé over for you.

For more information on résumé writing, check out Web sites such as http://www.resume.monster.com.

Craft Your Cover Letter

It is appropriate to include a cover letter with your résumé. A cover letter lets you convey extra information about yourself that does not fit or is not always appropriate in your résumé, such as why you are no longer working in your original field of employment. You can and should also mention the name of anyone who referred you to the job. You can go into

some detail about the reason you are a great match, given the job description. Also address any questions that might be raised in the potential employer's mind (for instance, a gap in employment). Do not, however, ramble on. Your cover letter should stay focused on your goal: To offer a strong, positive impression of yourself and persuade the hiring manager that you are worth an interview. Your cover letter gives you a chance to stand out from the other applicants and sell yourself. In fact, according to a CareerBuilder.com survey, 23 percent of hiring managers say a candidate's ability to relate his or her experience to the job at hand is a top hiring consideration.

Even if you are not a great writer, you can still craft a positive yet concise cover letter in three paragraphs: An introduction containing the specifics of the job you are applying for; a summary of why you are a good fit for the position and what you can do for the company; and a closing with a request for an interview, contact information, and thanks. Remember to vary the structure and tone of your cover letter—do not begin every sentence with "I."

Ace Your Interview

In truth, your interview begins well before you arrive. Be sure to have read up well on the company and its industry. Use Web sites and magazines—http://www.hoovers.com offers free basic business information, and trade magazines deliver both information and a feel for the industries they cover. Also, do not neglect talking to people in your circle who might know about trends in the field. Leave enough time to digest the information so that you can give some independent thought to the company's history and prospects. You don't need to expert when you arrive to be interviewed; but you should be comfortable. The most important element of all is to be poised and relaxed during the interview itself. Preparation and practice can help a lot.

Be sure to develop well-thought-through answers to the following, typical interview openers and standard questsions.

☞ Tell me about yourself. (Do not complain about how unsatisfied you were in your former career, but give a brief summary

of your applicable background and interest in the particular job area.) If there is a basis to it, emphasize how much you love to work and how you are a team player.

☞ Why do you want this job? (Speak from the brain, and the heart—of course you want the money, but say a little here about what you find interesting about the field and the company's role in it.)

☞ What makes you a good hire? (Remember here to connect the company's needs and your skill set. Ultimately, your selling points probably come down to one thing: you will make your employer money. You want the prospective hirer to see that your skills are valuable not to the world in general but to this specific company's bottom line. What can you do for them?)

☞ What led you to leave your last job? (If you were fired, still try say something positive, such as, "The business went through a challenging time, and some of the junior marketing people were let go.")

Practice answering these and other questions, and try to be genuinely positive about yourself, and patient with the process. Be secure but not cocky; don't be shy about forcing the focus now and then on positive contributions you have made in your working life—just be specific. As with the elevator speech, practice in front of the mirror.

A couple pleasantries are as natural a way as any to start the actual interview, but observe the interviewer closely for any cues to fall silent and formally begin. Answer directly; when in doubt, finish your phrase and look to the interviewer. Without taking command, you can always ask, "Is there more you would like to know?" Your attentiveness will convey respect. Let your personality show too—a positive attitude and a grounded sense of your abilities will go a long way to getting you considered. During the interview, keep your cell phone off and do not look at your watch. Toward the end of your meeting, you may be asked whether you have any questions. It is a good idea to have one or two in mind. A few examples follow:

☞ "What makes your company special in the field?"

☞ "What do you consider the hardest part of this position?"

☞ "Where are your greatest opportunities for growth?"

☞ "Do you know when you might need anything further from me?"

Leave discussion of terms for future conversations. Make a cordial, smooth exit.

Remember to Follow Up

Send a thank-you note. Employers surveyed by CareerBuilder.com in 2005 said it matters. About 15 percent said they would not hire someone who did not follow up with a thanks. And almost 33 percent would think less of a candidate. The form of the note does not much matter—if you know a manager's preference, use it. Otherwise, just be sure to follow up.

Winning an Offer

A job offer can feel like the culmination of a long and difficult struggle. So naturally, when you hear them, you may be tempted to jump at the offer. Don't. Once an employer wants you, he or she will usually give you a chance to consider the offer. This is the time to discuss terms of employment, such as vacation, overtime, and benefits. A little effort now can be well worth it in the future. Be sure to do a check of prevailing salaries for your field and area before signing on. Web sites for this include Payscale.com, Salary.com, and Salaryexpert.com. If you are thinking about asking for better or different terms from what the prospective employer offered, rest assured—that's how business gets done; and it may just burnish the positive impression you have already made.

Index